Making Pearls

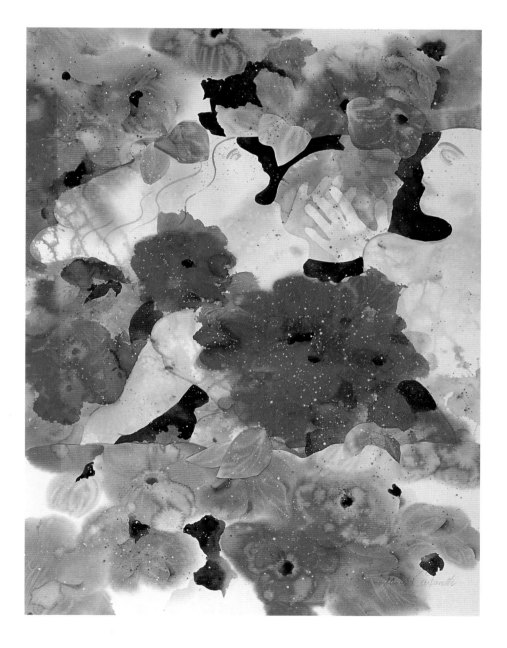

Making Pearls

LIVING THE CREATIVE LIFE

Jeanne Carbonetti

WATSON-GUPTILL PUBLICATIONS / NEW YORK

To The Wyoming Watercolor Society

Front cover
ORIGINAL BLESSING
Watercolor collage, 60 × 60" (23 × 23 cm), 1995. Collection of the artist.

Frontispiece
COMMUNION
Watercolor collage, 36 × 26" (92 × 66 cm), 1997. Collection of Sharon Denoff.

Title page
AUTUMN LIGHT
Watercolor on paper, 15 × 15" (38 × 38 cm), 1999. Collection of the artist.

Senior Acquisitions Editor: Candace Raney
Edited by Robbie Capp
Designed by Areta Buk
Graphic production by Ellen Greene
Text set in 10-pt. Palatino

First published in 2001 by Watson-Guptill Publications,
a division of BPI Communications Inc.,
770 Broadway, New York, NY 10003

Library of Congress Card Number: 2001090846

Manufactured in England

First printing, 2001

1 2 3 4 5 6 7 8 / 08 07 06 05 04 03 02 01

Acknowledgments

I wish to thank many people who have helped me birth this book:

Sandy MacGillivray for her speed and accuracy on the computer, combined with a geniune interest in the subject matter; artists Randi Dunvan, Rita Malone, Laurie Marsh, and Andy Swenson for sharing their artwork;

at Watson-Guptill, Senior Acquisitions Editor Candace Raney for her encouragement; Editor Robbie Capp and Designer Areta Buk for their expertise and exquisite sense of form and color in shaping this work into the printed page; and Ellen Greene for her fine graphic production;

and my husband, Larry, for his willingness to help me again and again with the chores of producing a book—and mostly, for believing in me. Thank you.

About the Author

PHOTO: ROD TULONEN

Jeanne Carbonetti, *whose watercolors are in many North American and European collections, instructs creative process workshops and teaches private and group classes in drawing and painting. She is the author of three previous Watson-Guptill books:* The Tao of Watercolor, The Zen of Creative Painting, *and* The Yoga of Drawing. *She lives in Chester, Vermont, where she owns the Crow Hill Gallery. You can learn more about Jeanne, her work, and her gallery at www.crowhillgallery.com.*

Contents

Prologue: When the One Became Two

Before the beginning of time, God was all things and all things were God. In the cycle of the seasons, in Heaven and on Earth, in day and night, in the birds of the sky and the beasts of the fields, all was one, all was flow.

But God was lonely and thought, "I wish to be recognized, to be heard." And so in God's image male and female were created, and they mirrored God's way. But it made the Great One sad. The Great One thought, "We are too much the same. I am not recognized."

Jeanne Carbonetti
HIDDEN GLADE
Watercolor on paper,
14 × 14" (36 × 36 cm), 1999.
Private collection, New Mexico.

Oneness within the world of forms teaches us that Heaven is really on Earth.

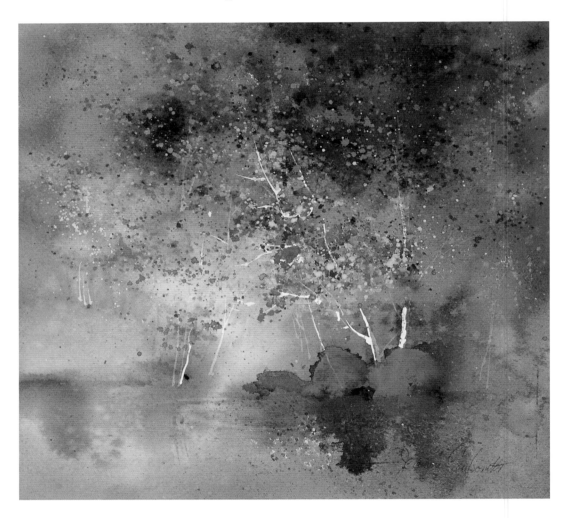

So God began an idea, and wanting to discuss it, brought forth the tree serpent, wiser than any creature, because it had shed its skin and been reborn so many times, it knew quite well the law of oneness.

Power of Choice

"Wise friend, I want to give humans the power of choice, for I wish to be recognized," said God. "I will cause a veil to come over their eyes, and the Tree of Life will appear to them as two. I shall tell them that they might eat of one, but not the other, that to eat of the forbidden one will change things forever."

"But what will make them choose the forbidden one?" asked the serpent. "Knowledge," said God, "for they are of me, and we wish to know, and to be known."

They worked out the details of the day the one would become two. Then the wise serpent asked God, "Suppose humans get so good at making choices, they forget to look for oneness? Then they will not recognize you behind the forms."

"But the world itself will give them clues," said God. "Heaven and Earth, day and night, the seasons—how could they not see the whole, not see me?"

"But," continued the serpent thoughtfully, "what if they get to like the two-sidedness so much that they want a good and bad in every situation? Perhaps they won't look past them to you."

I shall give them beauty, truth, and love to remind them," said God. "In beauty, they shall see oneness in the great harmony of nature; in truth, they shall see the law of oneness behind all other laws; in love, they shall see that within their uniqueness, they are really the same."

Power of Foregiveness

The serpent thought for a bit, then said softly, "My Lord, there is still one more thing. With their power of judgment, they might choose to call their learning 'mistakes'—failing to see that all is simple experiment and expansion." They might even call it "sin."

God was quiet, then spoke gently. "I shall give them the antidote for choice: forgiveness. Wholeness will always be possible then." But the serpent asked still more softly, "Suppose they choose *not* to forgive themselves?" At this, the great breath of God stopped, and all of nature was brought to a halt.

Knowledge

But finally, God's answer came as a sweet sigh. "That is the final choice: to choose to *forgive themselves* and to *love themselves*. In that moment, the doors to Heaven will open forever." God turned to his faithful companion and asked him to help the humans make their choice. "In return," God said, "I shall make you a symbol through all ages of healing and wholeness. People will see you on the Tree of Life, your first home, and will respect you." The serpent felt proud.

Now the moment came in Eden for the one to become two. It happened just as God knew it would. For God had said, "It must be Eve who chooses the fruit. For Adam comes from that part of me that loves to build and create new things. He will be so busy with his tasks, he will not be concerned with choosing. So much like me," God smiled. "But Eve comes from that part of me that seeks to relate all things, to make connections. I have seen her stopping to listen to the bird's song. So much like me. Yes, it must be Eve."

And so it was. The serpent took its place in the tree for the final time; Adam came and went, busy with his work; Eve spoke at length with the serpent, then finally, when she thought that the fruit of the tree of knowledge would help her understand all those things she found so special, she ate of the fruit.

Suddenly, the door at the east of Eden opened, and a great sun shone more brightly than ever before. Adam, who saw outside many things to be accomplished, quickly took a bite of the fruit and, with the tools he had invented, hurried out.

But Eve lingered at the gate, looking over her shoulder at Eden, then straight ahead at the world. She looked at the fruit for a long time, and then she held it to her heart. At that very moment, God felt a great swelling and shouted to the serpent, "She recognizes me! I AM!" Heaven and Earth grew great with light, and there was music in the spheres.

But as Eve lingered still longer, God and the serpent grew worried. "This is a crucial moment for her," said the wise serpent. "If she chooses to come back now, before learning the lessons of Adam or teaching him hers, she will forfeit choice again. There will be no world of forms through which you can be recognized." They watched closely, waiting.

After a long pause, Eve drew in a deep breath, and aware now of what she must do, took a large bite from the fruit and looked ahead to find Adam. As she turned to go, she whispered, "I will be back."

When she reached Adam, they took each other's hand for the first time, and for the first time, they called this feeling *love*. As time began, Adam and Eve walked away to begin their journey home. And all of nature could hear the breath of God saying, "Ah, perfect."

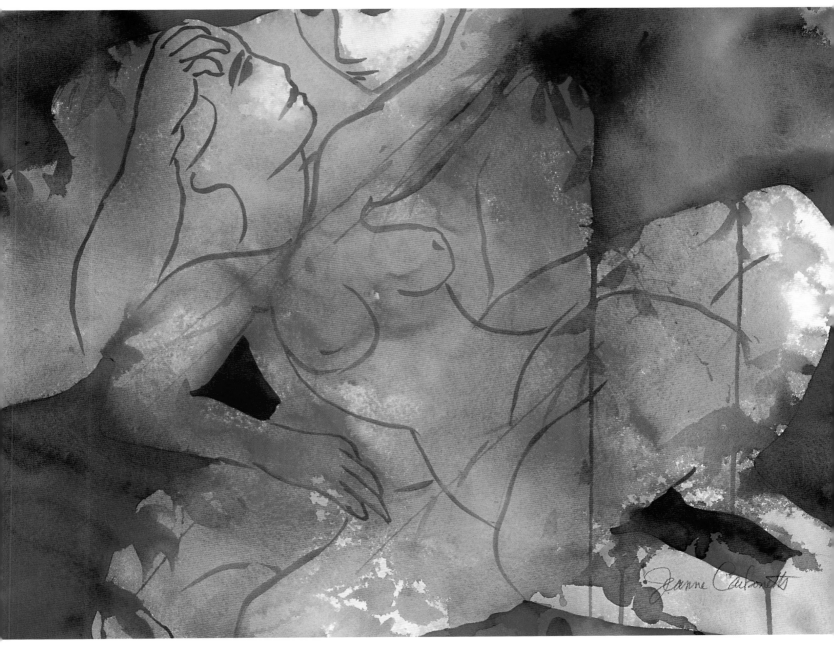

Jeanne Carbonetti

STUDY FOR EURYDICE'S DREAM

Watercolor on paper, 22 × 30" (56 × 76 cm), 2000. Collection of the artist.

Knowledge is being able to see past the choice of wholeness to forgiveness.

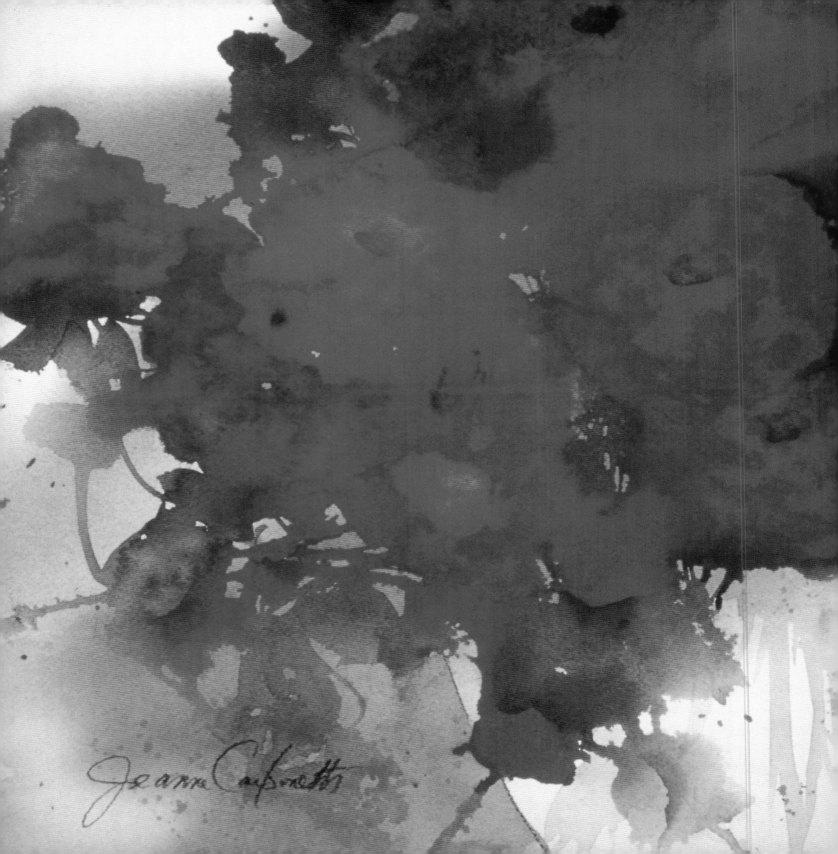

Introduction

The Pearl of Great Price

And the day came when the pain of
remaining tight in a bud was greater
than the risk it took to open.

Anaïs Nin

Jeanne Carbonetti
POWERFUL PEONIES
Watercolor on paper, 15 × 22" (38 × 56 cm),
1999. Collection of the artist.

*Every creative act is an act of faith and
courage. It is a faith in ourselves and a
fearless statement of* I am.

Creative Power Within Us

We are all creators. It is the birthright of each and every one of us; no one is left out. In our true nature as conscious beings, we shape our world through the power of imagination and thought. It is the original blessing of Eden. With the power of our free will we choose what we think about, and in so doing we bring through us, from the quantum field of potentiality, a new form. We are always thinking, choosing, willing, and thus creating.

But all too often we have seen the blessing as a curse, because the power is *always* with us. We do not plug it in and out like a videotape. Creation isn't something we do only on Saturdays or only when we take a class; we are creators always. When we are the least aware, we are creating the most. It is an awesome responsibility in this regard, for we must be ever mindful of our inner dialogue. Sometimes "remaining tight in the bud" seems safer.

Nor does life always seem to give us what we have willed, so even though we are creators, there is something larger at work of which we are a part, but not the sole director. We are part of a worldwide web of creative force. We affect each other.

Universal, Eternal Cycle

So how do we live with this power that is at once within us and yet enfolds us in something larger still? I believe it is by recognizing the cyclical nature of creative life, at once universal and eternal. Our true nature as creators is always in that cycle, never out of it. Every stage of the cycle is important: waiting, opening, closing, holding, releasing, emptying, sitting. Each has its gift. When we are in rhythm with the creation cycle, recognizing each stage and appreciating its special purpose, then we are in flow with our full creative powers. Work becomes joyful, always meaningful. When we are not in flow, it is because we don't recognize where we are in the cycle or do not appreciate it as a part of the whole process.

Certainly, we each have our favorite part of the cycle. Some of us love the freedom of opening, some the focus of closing. We all have stages that we like less. Some may find releasing harder than emptying, and most of us might squirm at the notion of just sitting. Yet, every part of the creative cycle is important to full manifestation. And, like ripples in the water, our habits in one cycle can affect future endeavors. We simply need to recognize where we are and honor it. This doesn't mean that every creation makes us dance, that there are no longer any mistakes, that the process is quick and easy. It is not. But confronting creative power brings an understanding that what we have seen as failure is simply the trail of our becoming, and each failure holds a gift if we can hear the beat of the rhythm that calls us.

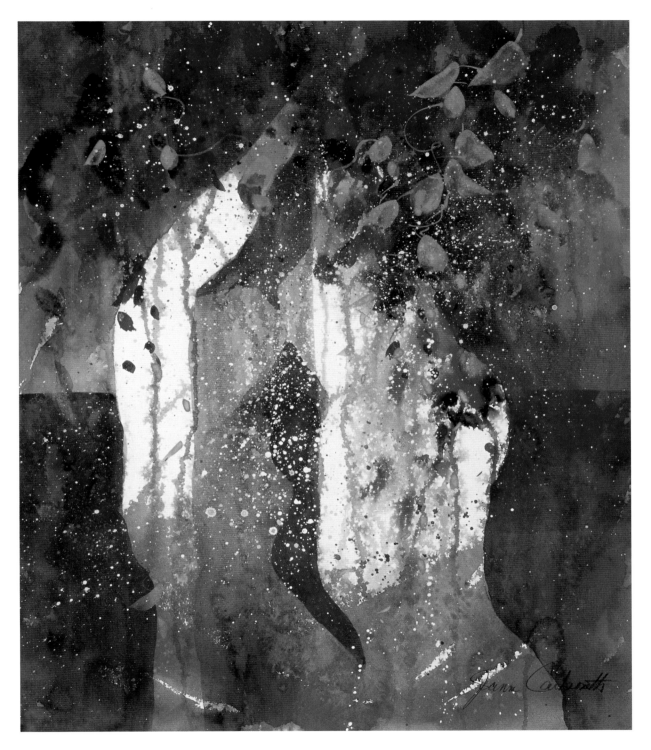

Jeanne Carbonetti
ISIS
Watercolor on paper,
25 × 22"
(64 × 56 cm), 2000.
Private collection,
New Mexico.

*Our work as creator
is to pull from our
spirits the intangi-
ble part of us out
into the light. Like
Isis in the myth,
we "re-member"
ourselves in the act
of creation.*

It is the great force of life *and* us who create, not one or the other, but both together. Life comes through us; true creation is always cocreation. More than magicians working from the mind of ego, we are wizards working from the world of soul, able to shape our world because we hear the greater rhythm that moves through us and encompasses us. Creation is always an act of faith—faith in ourselves and in that which is larger than ourselves. The song of Eden with its promise of creative choice is still within us, and we know its rhythm by heart.

So what is the rhythm, then, of creative life? I believe it is much like that of oysters making pearls. When instinct tells the oyster the time is right, it cements itself to something stationary and it *waits*. It waits for nourishment to come to it. I like to think that in its own oyster way it is watching, listening, feeling. But it doesn't seem to be doing anything. Then it decidedly *opens*, taking in water and all sorts of things as it filters out what it wants and what it doesn't want. When it is ready to "digest" its food, it *closes* its two shells hard and fast. It is now that some grain of sand lodges within the shells and the oyster works to integrate it by secreting its mother-of-pearl lining around it. The pearl begins as an irritation! As the oyster *holds* this pearl-to-be, the object rolls around freely within the closed space, which is what allows it to take on the roundness we know as pearl-like. Now comes the time of *releasing*, which always leads to *emptying*; everything goes along with the pearl. There is nothing left to do but *sit*. The cycle is complete; the pearl is beautiful.

Like Oysters, We Make Pearls

We make pearls every day in small ways, and over time, we make them in bigger ways. We are always in the cycle of pearl-making, forming out of the stuff of our lives something beautiful and meaningful—something we love. We, like our oyster relatives, must follow our instincts, and when the call comes, whether it be in the form of a beautiful question or a troubling dilemma, we must focus upon it and wait for signs that lead us in a particular direction. We may open ourselves to things we never thought of before. We choose to keep or discard them.

At the heart of the cycle of creation, we close, for now the grain of sand that is our perception must become ours completely, and we must keep our creation-to-be under our shell of protection. Then comes the time for holding. Oysters and creators keep at it and continue to hold on when other forms of consciousness give up. Then we must let our creation be what it will be in the world. It is no longer up to us; it is time to let go. So we empty ourselves of last-minute thoughts or changes or wishes; it is over now. This is the time for sitting—not even waiting—just sitting. If we resist this part of the process, it feels like a death, and we feel dried up, exposed. If we allow the mystery of the cycle to be as it is, we accept this part, too, without judgment—until the next call comes, and waiting begins again. In step with the rhythm, we let ourselves be where we need to be for as long as we need to be. Most of all, we must love ourselves enough to let that happen.

Love of Self

Loving ourselves is a choice we make, a choice we must make if we are to fulfill our destiny as creators. I am not talking about self-aggrandizement here but unconditional self-acceptance. The more we love ourselves, the greater our capacity for creation and our gift to the world. To the extent that we do not love ourselves, we will stop ourselves, judge our efforts, throw ourselves out of rhythm with the process, and literally block our efforts. Every hero in myth must choose to love himself, to stand for what he believes in, no matter what. Creatorship is hero's work, and we are each born with a hero's heart. For the journey that we are really on is the quest to uncover the pearl of divinity within ourselves, the unique point of creation formed *as* us.

Loving ourselves is facing ourselves, especially those parts that we usually hide until we are in the throes of creation. Meditation teachers tell us that the real purpose of meditation practice is to "be" with all those parts in a nonjudgmental way, reclaiming the parts of ourselves we have relegated to the shadows. It is the same for creators. We need all the parts of ourselves to create, and we need courage to love ourselves enough that it can happen.

Jeanne Carbonetti
BELOW LEFT:
MUSE WITH HARP
Watercolor on paper,
22 × 15" (56 × 38 cm), 2000.
Collection of Diane Thaler.

It may seem that the muse is elusive, but it is only that her music is subtle. For those who listen, the call is clear.

BELOW RIGHT:
FLUTE OF ORPHEUS
Watercolor on paper,
30 × 22" (76 × 56 cm), 2000.
Collection of the artist.

Through our own love, we awaken the beautiful music within.

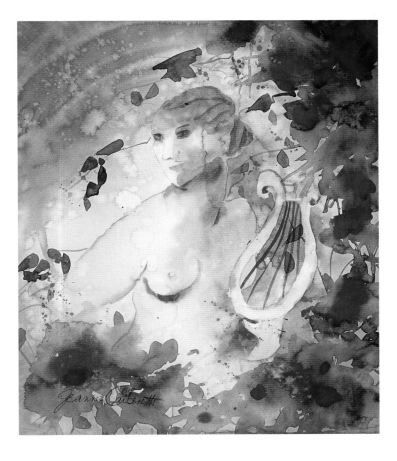

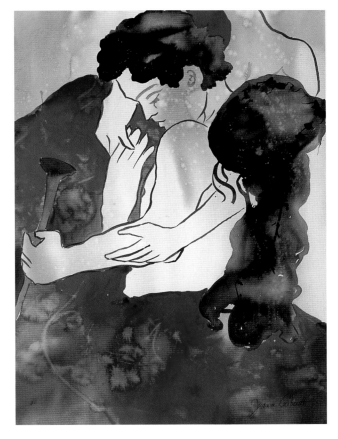

How to Use This Book

This book is about creating consciously, knowing that you are already a creator and now, through these pages, learning to recognize and appreciate each of the seven stages of creation. Each stage will be familiar to you because each is a natural part of your own true nature as a creator. You have already moved through each stage at some time in your life, but perhaps did not let the full power of its rhythm carry you. You may have felt blocked at times, uninspired at others, or perhaps frustrated and self-critical. All of these experiences come from not honoring where you are in the creative cycle. As you become conscious of the cycle of creation in your daily routine, you will learn to honor all the parts equally, and fall in step with the greater rhythm of creation.

Each chapter is divided into four parts. The first three—mind, body, and spirit—guide you in recognizing, practicing, and embracing each aspect of the cycle. A fourth part provides an artistic experience that is a synthesis of all three. Taken together, the first three parts form the basis of a practice in creative living, much like a practice in meditation. The process is meant to be simple and cumulative, and it is meant for everyone, in any walk of life. By just reading this book, you will become more mindful of just where you are in the creative cycle in all the areas of your life and more open to its special power for helping you. The point I most want to get across is that creativity is not something you add to your life; it *is* your life. It is the intangible part of us, the bigger part, that is given outward shape in solid form.

Putting Your Spirit Into Form

Thus, I include as the fourth part of each chapter a simple activity for putting your spirit into form; in other words art, which will combine to make a major piece of art when the book is finished. Whether you are a practicing artist or a novice, whether you are interested in art or not, this simple activity will deepen your understanding of the creative cycle in a transformative way.

The transformation has nothing to do with becoming a creator, for you already are one—but in how you see and trust yourself as creator; that is everything. If you have ever felt yourself to be uncreative or unoriginal, have felt blocked in your ability to create, or have felt fearful of showing yourself to the world in your own way, may this book help you to see and trust your true nature: You are a creator by birthright and a maker of pearls.

What's Ahead

You will soon notice that each chapter features a particular color that is most prominent in the paintings shown within those pages. Taken together, these colors form the palette that you will use as you make your own pearl of art, built up from chapter to chapter. The lively examples shown below, created by artist Rita Malone, preview the colors you will be working with, and what each symbolizes within the creative cycle.

BELOW: Rita Malone
CREATION CYCLE
Watercolor on paper, each,
7 × 7" (18 × 18 cm), 2000.
Collection of the artist.

WAITING
Red: life-blood.

OPENING
Orange: womb of ideas.

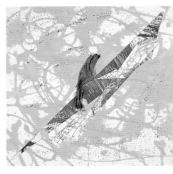

CLOSING
Yellow: power, presence.

HOLDING
Green: growth, nurturing.

RELEASING
Blue: expressing truth, voice.

EMPTYING
Violet: wisdom, insight.

SITTING
White: faith, peace.

1
Waiting

It is when I seem to be doing the least
that I am doing the most.

Leonardo da Vinci

Jeanne Carbonetti
CANADIAN AUTUMN
Watercolor on paper, 10 × 10" (26 × 26 cm),
2000. Collection of the artist.

*It is good to be mindful during the prac-
tice of waiting, for the smallest of things
can speak with the loudest of voices, and
what was always here, you now find you
can see—for the first time.*

The Nature of Waiting

The first stage in the cycle of creation is that of waiting. Waiting is very different in nature from sitting, which is the final stage in the process, for it is really quite active, rather than passive—but it is an internal, rather than an external, mode.

For the oyster making a pearl, waiting is characterized by two events: it recognizes instinctively it is hungry; then it literally cements itself to a surface and waits. For the human pearl maker, waiting is when you hear the first stirrings of intuition that seem to beg for development—the tug of instinct that gnaws in the gut, a restlessness, perhaps an anxiety. This is the life force tapping you on the shoulder, asking to be engaged, whispering in your ears, "It's time for this, now."

It is the creator's obligation to answer this call, and the way that you do this is by consciously waiting for signs, listening between words for the ones that make your ears perk up, looking to see what makes your eyes light up, waiting to feel your tummy jump. It is about getting in touch with your deepest longing in the present moment and honoring it by bringing it forth through your words, even if they are only for your own ears. Your true desire is always a call from the divine, from your muse.

This naming the question is not of the order of mere labeling. Quite to the contrary, I believe this is the first movement of powerful vibration that physically activates the creative process toward your choosing. Creation stories from many cultures have references similar to the biblical, "In the beginning was the word." A word gathers, with laserlike focus, one's intention, and from this the world changes shape: "And God said, 'Let there be light', and there was light." Speaking the word brings potential life into form—getting in touch with the muse.

For me, the muse is the three-fold voice of the family of the self, which I believe exists in each of us. What you are doing when you are waiting is quieting yourself long enough to hear those voices, which I call Logical Mind, Body Mind, and Heart Mind. Logical Mind is the father in each of us, speaking through the voice of thinking and reasoning. Body Mind is the mother within us—the gut feeling, the dream, the body sense of something at hand. Heart Mind is the child within that speaks through the world of play and imagination, expressing fantasies and deepest longings. All three voices need to be honored. When they are, you are fully present to the task of clarifying what you are really waiting for.

If, like the oyster, you seem to be cemented to where you are and not moving, say, in a way acceptable to your boss or relatives perhaps, what does waiting look and feel like?

First Stirrings

First, I can tell you from much experience, the world goes into soft focus. Though I pride myself on being a very productive painter, when I am in the cycle of waiting, I am non-productive, at least as seen from the outside. What I am doing is paying very close attention to the slightest stirrings internally that will guide me to the next step. In all my major series of paitings, I have come to realize that an image and a word phrase float through my mind. Before starting a series I called "Eden," I began to be aware of the image of a garden path and the word *utopia*. Had I been busily engaged in something "productive," I might have missed those stirrings. During this period of soft focus, I do much more listening and watching than talking and doing. I step out of the circle of "normal" logical world planning and executing, and I enter a foggier, more subdued, subtle world. It is a place of being "in the world but not of the world," to quote the Gospels, and yes, it is in this stage when I most fit the classic stereotype of the artist who is "out there." I need to be out there. That's where the deeper voices come from.

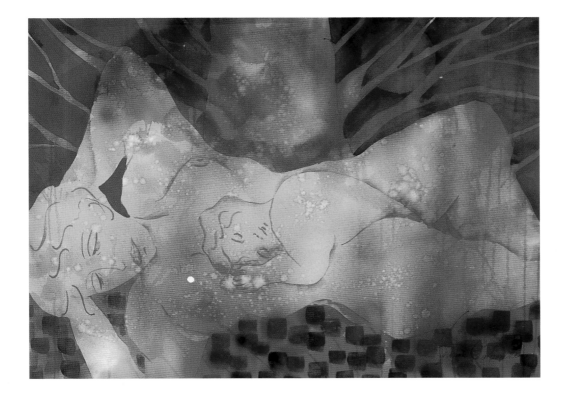

Jeanne Carbonetti
THE BIRTH
Watercolor on paper,
22 × 30" (56 × 76 cm), 1994.
Collection of the artist.

It is said that following birth, babies should not be exposed to too many different energies. For a period of time, it is best to keep them close to home. So it is with the stage of waiting—a time for letting a creative baby grow in the protected environment of your own heart, without exposure to the world just yet.

Embrace Uncertainty

Along with a softer focus on life, a person in the stage of waiting has a greater tolerance for uncertainty. Though some anxiety and restlessness may arise, for the most part, the creator has faith that something is coming, even if it's not yet clear. Rollo May, in his lovely book *The Courage to Create,* states that artists do not create because they have no uncertainty; they create *in spite* of that uncertainty. In other words, creativity is not all fun and games, and we sell ourselves short when we cut ourselves off from a full cycle of creation by assuming that it must be completely carefree to really be a creative endeavor.

Sitting with uncertainty takes patience. Sometimes the inner voices we listen for are farther away, down deeper. I have noticed that with every major thematic series I have done through the years, the period of waiting gets longer, because I am going deeper with each one, and I now recognize that there are more pieces to the puzzle of my vision in every series.

While the stage of waiting may look like self-indulgence and selfishness, it is really transpersonal consciousness, reaching out to everyone. Our obligation as creators is to go so deeply within ourselves that we come to the core of humanness. We journey to the center of ourselves, and we find the world there. It is a kind of research that every creation begins with, whether it is to become a painting or to become a cure for cancer.

Jeanne Carbonetti
BIG, FAT PITCHER
Watercolor on paper,
16 × 22" (39 × 56 cm), 1998.
Collection of Jill Carbonetti.

There is a reward in waiting until your vision is clear. When it is, you look as full as the Cheshire Cat, for you feel *the possibility of your dream fulfilled.*

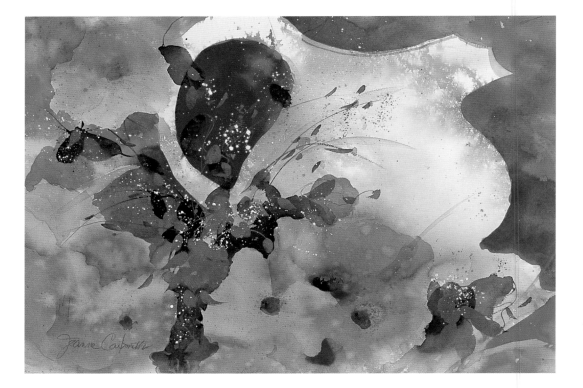

The Practice of Grounding

So how does one cultivate the art of waiting? It is most easily accomplished by becoming grounded—the equivalent of the oyster cementing itself to one object. The purpose? Grounding is meant to stop you from running around in many directions, to begin funneling energy into one thing, namely your receptive self. As you wait for signs, you want to be alert in all parts of your consciousness so that you may receive them.

There are several ways to practice groundedness. To get a feel for it, simply engage your physical senses. Allow yourself to feel your feet as they touch the floor; to see the pattern on the sweater you are presently wearing; to hear the sounds of your environment consciously. This puts you into present time and aids your awareness, so that you are able to receive an insight, should it come. Being in your body in this way actually frees your mind, because it keeps it from traveling off too far afield. One of the most important concepts in waiting is that you are waiting *for* something—it is not mindless wandering, scattering your energies. It is rather like the silent deer with ears perked up, listening.

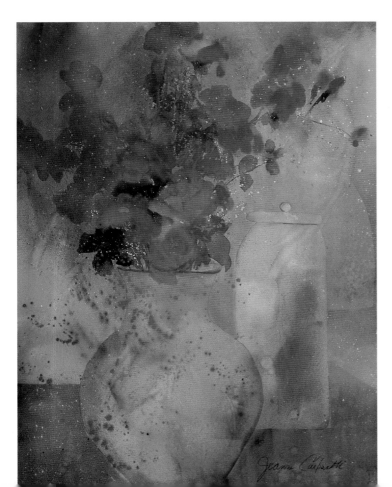

Jeanne Carbonetti
VOLUPTUOUS VASES
Watercolor on paper,
30 × 22" (76 × 56 cm), 2000.
Collection of the artist.

There is a fullness to waiting. We can learn to sense a voluptuousness in our bodies, as a mother-to-be senses her oncoming labor: "It is time."

Another way to stay grounded is to watch your breathing and notice its rhythm. Let that rhythm carry you for awhile; it will keep the world from running away with you. It is like your own internal alpha-state regulator. Alpha waves are emitted from your brain when it is in a state of heightened receptivity. Helping your brain get there by the relaxation of rhythmic breathing is a lovely way to open yourself to the power and pleasure of waiting.

Private Space and Time

Being grounded in your body, however, goes beyond your physical frame. When the oyster is hungry, it first cements itself to a particular place, carving out its territory and saying, "my space." Likewise, as a creator, you need a place that is yours alone in which to wait—a place of quiet, of calm, of peacefulness—and controlled by you alone. The Chinese art of placement, *Feng Shui*, suggests that this can build up vibrations of energy in your special space that are resonant with creation. This really makes common, or grounded, sense. In my case, my studio is linked to my house through a front porch. Each time I cross that porch, I am aware of the transition from "our space" to "my space." It is a valuable distinction. Not even my mother will follow me there.

Though it may not be easier, getting grounded is also a matter of time. You need to be fully present and in your own space for your own space of time. Carving this out of the American work ethic is a Herculean task, but it is essential to creators. You simply must *take* time if it is not freely given to you, for doing what you must do—which here means waiting and *not* doing.

Contemplative Thought

With private time, thinking in a grounded way that invites inspiration is much more contemplative than logical and linear thought. Logical thinking is for a specific purpose, and is directed outward; it already has some goal in mind. Contemplative thinking, on the other hand, is curvilinear, like an S-curve, which in visual vocabulary is considered the most elegant and beautiful of lines. The purpose of contemplative thinking is to experiment, to see where it takes you, which is left open to surprise.

One of my favorite ways of waiting for inspiration is to contemplate a master's art. I will flip through an art history book quickly and notice what draws my eye. Whatever I notice, I will pause to contemplate, and watch how my thinking wanders, which may offer an opening for insight and inspiration to enter. Or I might go to clip branches in the woods behind my house while I contemplate—alone. Clipping branches adds a rhythmic quality to my meandering thoughts, and the rhythm of it all begins to carry me to new territory. What I do *not* do is visit with someone, either in person or on the phone. That would throw my energy around, when what I am intending to do is give just enough pressure to generate flow.

Reflective Thought

Even more curved than contemplative thought, reflective thought is, in fact, a circle. Its purpose is to go back and underneath a subject with the hope, if you will, of finding a pearl. Reflective thinking acts as a mirror, showing us where we were before and where we are now. Hindsight, a form of reflective thinking, closes the circle and brings you back to where you started, but with greater knowledge.

Reflecting upon a past painting series is a valuable endeavor for me whenever I am in the stage of waiting. It allows me to see patterns I may never have seen before, and I am always amazed at the insights that come to me long after a series is complete. New levels of understanding emerge that I did not comprehend when I created the paintings.

Along with personal time and personal space, both contemplation and reflection are ways to ground the mind and body by becoming more aware of your own processes. Grounding yourself in spirit is accomplished by watching those processes directly—to be wholly present in yourself so you can be attentive in the art of waiting. Like the oyster, we become planted in our bodies when we consciously engage our senses, in our minds when we consciously engage our thoughts, and in our spirits when we consciously engage our imaginations.

Jeanne Carbonetti

BELOW LEFT:

AUTUMN HARVEST
Watercolor on paper,
7 1/2 × 5" (19 × 13 cm), 2000.
Collection of the artist.

If the wilderness calls, we need to respond. Creators do not unlock the mystery of creation; they simply enter it more deeply.

BELOW RIGHT:

STATELY BIRCHES
Watercolor on paper,
18 × 13" (45 × 33 cm), 2000.
Collection of the artist.

The groundedness of the waiting stage sends your roots deep into the earth, giving you the power to grow.

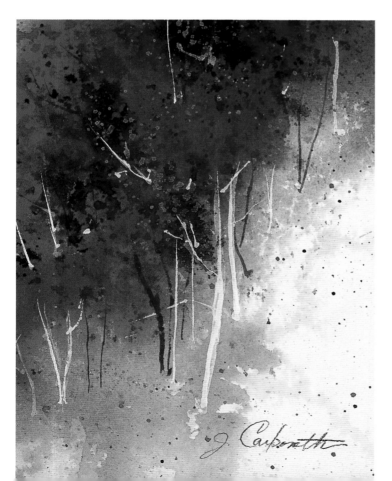

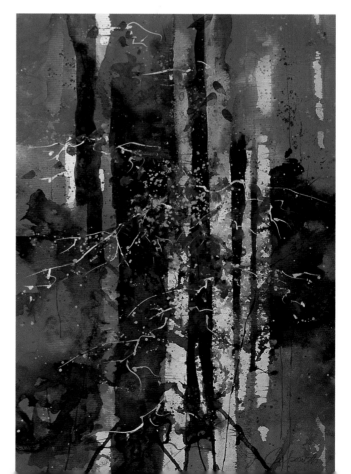

Visualization

A powerful tool available to us in the art of waiting is the ability to visualize. For example, I often visualize a garden where I sit and wait for someone or something to come and speak with me. The concentration of visualizing grounds me into an attentive soft focus. As clues begin to come, I play a bit more with my visualization, seeking direction, as though I were trying on different hats to see which looks and fits best. It's a time to let images evolve. You can play with them, letting them become what you want them to be, or you can let them go if they lose interest for you.

Of my favorite places for concentrated thought, I especially enjoy visualization when I'm soaking in my tub, a great time for pearl-making. Try it, and allow yourself to dream your dreams! One of them will take hold of you—and you will feel it. Then you will know it is possible. Then you will know the waiting is over.

Jeanne Carbonetti
TENDERLY

Watercolor on paper,
30 × 22" (76 × 56 cm), 2000.
Collection of Pat Magrosky and
Rod Tulonen.

The yin and yang of us, our own female and male sides within, must be in loving relationship for creation to flow, for the nature of their relationship is the nature of the process.

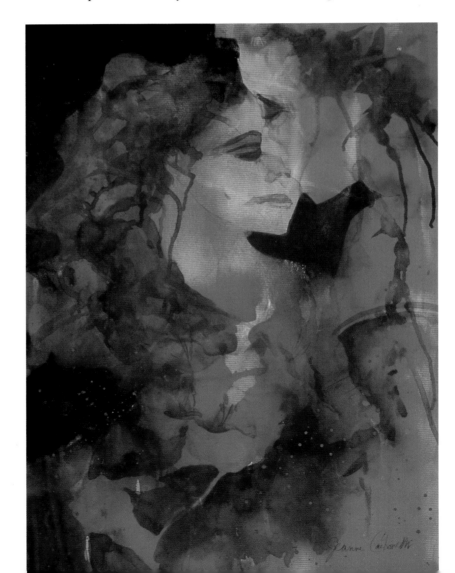

The Gift of Patience

The particular beauty of the stage of waiting is that it honors the truth that being is fundamental and prerequisite to doing. It is a potent reminder to our own culture, as a creative one, to honor waiting as much as we honor doing.

The gift of spirit that we attain in the stage of waiting is patience. It is the first and foremost lesson for the creator, because it heightens our receptive capacity. Inspiration always comes from a larger, wider mind than immediate, sharp-focus thinking. And it takes longer for it to travel that distance!

Creators know to wait until they are pulled toward something, rather than pushed through, to get something done. It is an important distinction. When we are pulled toward something, all parts of ourselves are engaged—Logical Mind, Body Mind, and Heart Mind—wholly ready to move forward. To need to push means that some part of ourselves has a reservation. Patience allows us to see these distinctions clearly and not act before it is time.

Finally, patience allows us to sit comfortably with a period of little clear direction, keeping faith that it will indeed come again. I can promise you, it will.

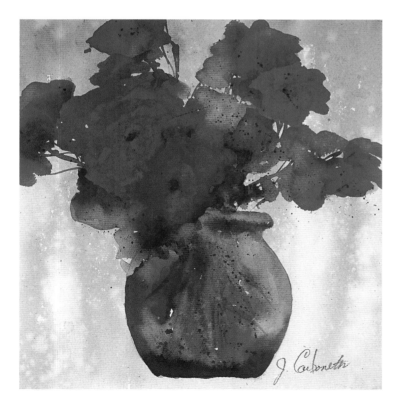

Jeanne Carbonetti
SUMMER FLOWERS
Watercolor on paper,
9 × 9" (23 × 23 cm), 2000.
Collection of the artist.

Some creations are big, while others are small. They are equally important in the creative life, however, for they are both mirrors of our process.

Jeanne Carbonetti
**WOMAN SITTING
WITH APPLES**
Watercolor on paper,
21 × 15" (53 × 38 cm), 1994.
Private collection, Vermont.

*We need to wait until our vision
grows clear. Simplicity is the art
of waiting until the essential
presents itself.*

A Symbol for Waiting

*On my coffee table sits
my symbol for waiting, a
copper sculpture of an angel
by Vermont artist Mary
Eldredge, a treasured gift from
my husband. Each morning
and evening I kiss my angel,
a kind of mini-ceremony to
remind me that Earth is
Heaven, too—a truth I don't
want to forget, and my angel
doesn't let me. She reminds
me that only by being fully
grounded on Earth can I
fully express through form
the beauty of Heaven.*

*What physical symbol
would be your own
meaningful way to honor
the stage of waiting in your
creative life? I encourage
you to find a symbol that
embodies the aspect of
waiting that most speaks to
you. Enjoy your symbol; let
it speak to you. Know that it
will increase your capacity
for creation, for seeing
symbolically is central to it.
You will truly be surprised
at what you will learn.*

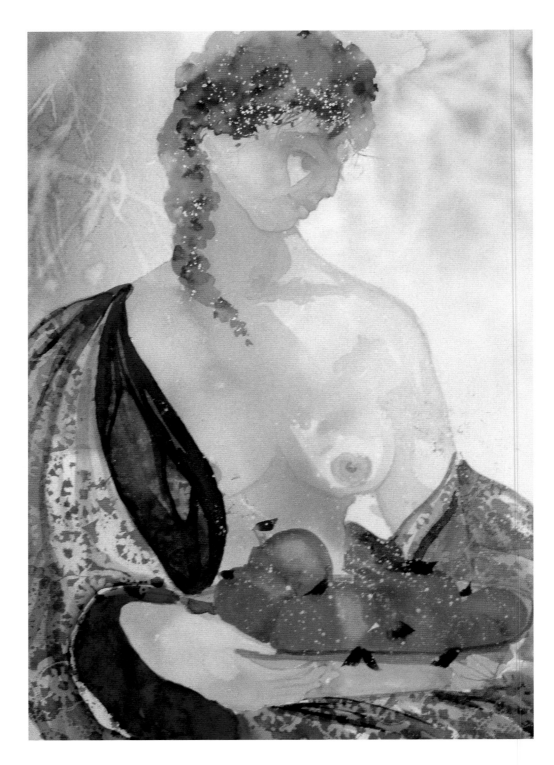

The Power of Art: Creation Cycle, Part I

Whether you are an artist or have never created art before, this simple art project offers you a lovely microcosm of the full creative cycle. By adding one square to a piece of art as you move through each chapter, you will experience the cycle of creation and the joy of making a form that is meaningful to you.

The art piece that you build through these pages can be framed singly as one work or as a series of eight individual pieces. In either case, your artwork will embody a meaningful representation of the creative cycle moving through you.

It will please you to see how this exercise process leads you to create the way creators do, by letting life move through you into a form that is uniquely you. Along the way, you will see examples of how others developed their unique creation cycles.

Example, background only: *To illustrate this simple process, here is just one of many ways to prepare the first square described above. In this case, I used red watercolor of various shades.*

Example, completed square: *Artist Laurie Marsh also chose watercolor for her first square. Then, as she developed it, she added collage and incorporated words that represent to her the stage of waiting.*

Supplies

- Good-quality watercolor paper.
- Any medium you choose (watercolor, pastel, crayons) in colors of the rainbow.
- Pen or marker, any color.
- Magazine pictures for collage (optional).

Directions

- Cut 8 pieces of paper into 7" squares.
- Color a square with one or several shades of red, the symbolic color of our root, our life-blood. (Save the other squares for later.)
- On this square, draw, paint, or paste whatever words, images, or symbols represent the stage of waiting for you. Let it unfold over time. As you move through the book, come back to this square and add or change when it seems appropriate.

2
Opening

True artists scorn nothing.

Albert Camus

Jeanne Carbonetti
LATE SUMMER FIELD
Watercolor on paper, 9 × 6" (23 × 15 cm),
2000. Collection of the artist.

One of the most important principles of
opening is to allow what excites you to
fill you up without questioning where
it's going to lead. If it is important
enough, it will become clear in time.

The Nature of Opening

Where the primary characteristic of the cycle of waiting is staying still, it is movement that begins the stage of opening and is intrinsic to it. For the oyster preparing to make a pearl, two important functions take place now: one is to feed, the other is to filter. The oyster knows it is hungry, so it opens up to see what comes in. Some things it keeps, some things it doesn't. In this stage of experimenting for food, elimination is a prime activity, so the oyster takes a lot in without discriminating. For the time being, "more is better."

So it is with us at this stage of pearl-making. Earlier, while waiting, we were still enough to hear the murmurings of the beautiful question: What am I hungry for? And the answer: Ah, yes—more soulful connections in my life. Now we are ready to see where the beautiful question/answer will lead us. The key word here is rhythm—playing enough that you begin to sense what you are in step with, and what beat can carry you further.

Research, Develop

I always think of opening as starting to collect the pieces to a puzzle. For example, when I began a painting series that I called "Water and Mist"—which began with the question, "How can I show that we come from spirit?"—I began reading everything I could about artists and their works that I felt had a connection to water. It led me to the sculpture of Henry Moore and then to a fascination with Japanese paintings of water.

I think of this stage as "R&D." Just like scientists who research and develop, all creators are meant to be free to explore lots of paths, many of which may lead to dead ends. But that's fine, for this is not the stage of commitment. Instead, I talk with colleagues, bat ideas around, get downright chatty, while in other stages, particularly waiting and closing, that is not the case at all. As I continue to play with whatever seems right in the moment, I begin to notice that one idea or image has more weight, like a deeper beat that organizes music, and so my own images begin to constellate into patterns. But what is extremely important for me in this period is that I remain willing to give it all up if I lose the rhythm of it and something else comes to take its place.

Jeanne Carbonetti
**MOTHER, CHILD,
LANDSCAPE**
Watercolor on paper,
25 × 22" (64 × 56 cm), 1989.
Collection of the artist.

*Let the stage of opening take
you to unexpected places. As you
learn to open to your idea, so the
full power of your imagination
will open.*

Invite Whimsy

In the stage of opening, then, we need to allow ourselves to be carefree, tentative, curious, playful—even whimsical—and willing to remain in limbo, with nothing to show for it concretely until the rhythm of a sweet sound of an idea carries us away. The stage of opening employs the full power of your imagination. It is the time to let your daydreams, your night dreams, and your fantasies all have their say. Many will fall away, but out of them, something will trigger a resonance deep within, and that is your signal to explore more deeply. Out of this will come the stuff for making pearls.

Jeanne Carbonetti
VERMONT AUTUMN
Watercolor on paper,
22 × 22" (56 × 56 cm), 2000.
Collection of the artist.

The word enthusiasm *originally meant "kissed by the gods." The implication here is that our sense of deep connection is a call from our divine nature; that desire is the god seed in us.*

Jeanne Carbonetti
SEPTEMBER ZINNIAS
Watercolor on paper, 9 × 10" (23 × 25 cm), 2000. Collection of the artist.

The stage of opening can be a lovely, mellow stage—if we allow ourselves the time to wander. At its best, it allows us a space to move languidly among different alternatives until our pace begins to quicken. Then we can easily recognize when we are moved by something into the state of enthusiasm.

The Practice of Connecting

How does one assimilate and make a practice of opening in creative life? If you find yourself with some notion or question that haunts you and won't let you go, you are most likely ready for scanning, sensing, and sign reading—three valuable methods for allowing the spirit within your creative core to guide you to your perfect work for the present moment. The practice of connecting is about finding the way you wish to relate to the issue that has your attention. As possibilities present themselves to you, you become skilled at recognizing what has a resonance for you, and what can be filtered out. Like the oyster, you take in a lot, let go of a lot, and begin to hold on to what nourishes you.

Scanning

A wonderful way to recognize the common denominators that are already present in you and wanting your attention is by scanning—moving very quickly through several references, noting your preferences immediately, without thinking. When you have finished, go back over those you've noted, and you are sure to find a pattern of preference. This is extremely helpful in guiding you to what you are really after. At home, I will fly through my art or travel magazines, literally ripping out pages with abandon. Sometimes I'll make two piles—one for those that attract me, the other for those that don't. It's a quick and clear way for discerning where you are.

When I'm in New York, I do a similar kind of scanning at museums. I move steadily through several rooms of art, sit down for a moment and reflect upon the works that stand out to me, then go back to those pieces and spend more time with them. On every museum visit, different pieces call to me, showing me a mirror of my own evolution. For a painter, this is powerful information.

Scanning is a simple, remarkably enjoyable procedure that is applicable to any kind of activity where opening to new directions is required. An architect friend of mine does the same kind of scanning with furniture stores, city streets, and magazines; a writer friend, with bookstores. It's not new; we all scan a great deal of the time. What is new, perhaps, is the added reflection that seeks to find meaning in it all. Here, we are in the realm of pearl-making.

Sensing

One step more subtle than scanning is something you do with no props other than your own seven senses. Yes, I do believe that we have at least seven, and they are always giving us valuable information—but we must value such information to receive the gift.

First, of course, are the five senses of our Body Mind: seeing, hearing, smelling, tasting, touching. As you become grounded and more fully present in your own body, you notice that these senses are giving you more information than you had previously realized. The signals are spontaneous and generally quite clear as we become more attuned to them.

There is also the sixth sense of intuition, which I imagine to be housed in the third-eye center, located between the eyebrows, in the area of the pineal gland. In the Hindu Chakra system, this is the energy center of intuitive wisdom, knowledge that comes to us through inner vision. I believe that we all come equipped with the innate ability to use this sense, but those engaged in a conscious practice of creative life access and trust it more readily than those who do not. It is not that those who lead creative lives are naturally

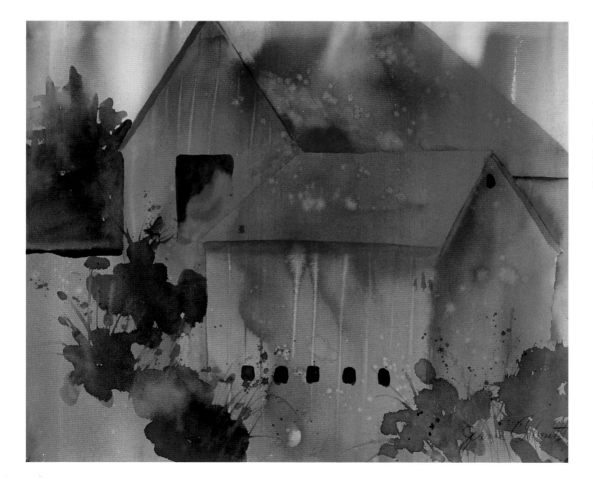

Jeanne Carbonetti
BARNS
Watercolor on paper,
18 × 19" (48 × 49 cm), 1999.
Collection of the artist.

What you are really doing in the stage of opening is warehousing a lot of ideas. Like a barn full of young animals, you're waiting to see which are the noisiest and most full of life.

more intuitive. Rather, those who choose to practice creative living consciously, naturally develop this sense. It is an important distinction. Remember, we are born creators, but we can choose to create consciously or not—that is the difference.

Intuition comes to us from Heart Mind, which opens us to our own spirit. At this level we are able to access deeper dimensions of reality, which lead us to the seventh sense, love. As we develop the perception of love, or unity consciousness, we become attuned to recognizing the special gifts of all other beings of consciousness. This, in turn, renders us capable of relating to a much broader spectrum of life from an "I/Thou," rather than an "I/It," perspective. Thus the old judgmental labels that so easily categorize our reactions to people or situations begin to have less hold, and suddenly we are "open" to learning from places we might not have expected. Practicing loving as a sense perception is a valuable endeavor, and it opens you to a wealth of information—if you are open to signals. Words may come to you, out of context, from someone's speech. You may hear the same interesting tidbit from three different sources within a short period of time. Even a fortune cookie may speak uncannily to just your present situation. You have only to trust the signs that you receive.

Go with the Flow

Is opening a natural stage for you in the creative cycle? Is it easy for you to play with ideas without having them become something "useful" immediately? Or do you tend to get stuck in this stage because you like keeping all your options open all the time, so you never give yourself a chance to resonate with one thing deeply? There is a dynamic balance to both of these polarities. As you begin to honor the stage of waiting more and, with it, the practice of grounding, you will find that it will be a little easier to let opening be more rhythmic and gentle rather than frantic.

Is there something in your heart and on your mind right now? Has it formed itself into a beautiful question, or a goal, or a need? If it is not yet clear, allow yourself more time for grounding and waiting to be sure. If it is clear, begin to open by practicing scanning, sensing, and looking for signs. With your question or goal clearly in mind, it will be easier to open in this way. Remember: No place or situation is too mundane for magic. Listen and watch, with grounded feet and open heart.

For the next day, week, or month, let yourself steep in these practices. This will open you not only to a deeper dimension of your world, but to a deeper dimension of yourself as well. Finally, allow yourself to explore the theme of opening by enjoying the art in these pages, as well as in other places. Because art is a poetic language, it is able to give you several layers of meaning at once, and you can receive even more whenever you return to it. May you open with the certainty of a rosebud in the summer sun.

The Gift of Enthusiasm

In its root meaning, the word *enthusiasm* describes a state of being "touched by the gods." That is exactly what we seek in the stage of opening: to be divinely in love with an idea. The idea needs to be so wonderful that to think of it lifts you off your feet, excites you even in a sensual way, and pulls you toward it. The notion of being pulled rather than pushed is of paramount importance here. I believe it is the truest test of whether we are creating from our core, our soul.

If we are *pulled* in a direction, we find ourselves filled with energy and momentum. We can go on for countless hours without stopping, without getting tired. This is a sure mark of enthusiasm and the kind of connection that must be present for true creativity to emerge. When we are genuinely enthusiastic, we touch our core, stimulating an energy there that is ever-renewing.

On the other hand, when we are *pushing* or being pushed, then we are not in the realm of soul but of ego, forcing something to happen because it is the acceptable way to move. In the stage of opening, it is best to let such endeavors go, because only true creation is good for the whole—and only that which excites us is born of that truth.

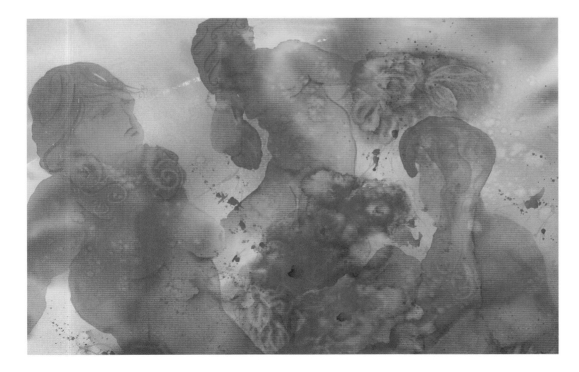

Jeanne Carbonetti
SONG OF THE MUSE
Watercolor on paper,
22 × 30" (56 × 76 cm), 1999.
Collection of the artist.

Sometimes the song of the muse seems to pull us in opposite directions at the same time. But if we keep listening, eventually, a harmony between them will play out.

The Power of Art: Creation Cycle, Part II

Following the directions given earlier (see page 29), create a seven-inch square of an
orange color, which is the hue generally associated with the womb of ideas. In the Hindu Chakra system, orange is the color of the pelvic center of the body. Into this square, put whatever words, images, symbols, or marks best describe what is most meaningful to you about the stage of opening. Remember, do not push. Let what pulls you come freely, and in its own good time.

A Symbol for Opening

My symbol of opening is very special to me: an open rose, cast in silver, with my engagement diamond in the center. The rose itself is a powerful symbol of flowering. With a diamond at its core, it is an ever-present reminder of the power of art and the creative process to unfold the jewel within.

What symbol will you adopt for the concept of opening? Let it be the embodiment of what you cherish about this aspect of life. Every time you look at it, you will be reminded of the power and gift of opening. Put it in a place where you can see it often. Allow the symbol to be the way your greater consciousness, or muse, comes to you—even at the most unexpected times. You might be in line at the supermarket, when across your mind floats your symbol of opening. Consider it a call from the Angel of Opening. The time might be ripe for looking for signs!

Example, background only: *For my stage-of-opening square, orange watercolor flows freely, offering a base on which to build.*

Example, completed square: *Andy Swenson combines watercolor, collage, and words to express his concept of the stage of opening.*

OPPOSITE: Jeanne Carbonetti
FIRE AND ROSES
Watercolor on paper,
25 × 22" (64 × 56 cm), 2000. Collection of the artist.

When an idea lifts you off your feet with excitement and pulls you toward it, you have arrived at the joyful stage of opening.

Meditation

*Allow yourself a morning,
an afternoon, or a whole
day for this treat.*

*Take a deep breath.
Center yourself by focusing
on, thinking about: your feet,
then your abdomen, then
your head, then your heart.*

*Picture a lovely ball of
clear orange light bathing
your pelvic area in gentle
warmth. Orange is a univer-
sal color of attraction and
connection.*

*State clearly, aloud if
possible, your desire that the
time you spend during this
meditation will open you to
see whatever you experience
with new eyes, in a new way.*

*Notice whenever you
find yourself falling into old
labels, just reacting rotely.
Restate your intention, and
begin anew.*

3

Closing

What's a man's first duty? To be himself.

Henrik Ibsen

Jeanne Carbonetti
SECRET COTTAGE
Watercolor on paper,
15 × 13" (38 × 33 cm), 2000.
Collection of the artist.

*This is the time to separate oneself, to be
alone, even to be secretive. Where once
talking was a way of testing our own
waters, now silence is the blanket with
which we protect our dream as it grows.*

43

The Nature of Closing

Now the oyster closes. A large, central muscle serves to close the two valves of its shell against the pull of the ligament. The filtering process becomes more directed, and digestion of food particles can take place. Only the smallest opening can be detected now. For all intents and purposes, the oyster has closed itself to the world to accomplish its inner work.

What goes on now inside that shell is crucial to pearl-making. The first thing that happens is that some piece of foreign matter gets lodged inside that can't be easily digested. In other words, it is an irritation to the oyster, and the bivalve must give a great deal of attention to it. It does this by secreting its mother-of-pearl lining around it. In this way, the oyster makes more of it, indeed makes something out of it that is fully integrated with its own essence. The two polarities—foreign matter and oyster—become one in the pearl. Now the oyster makes meaning out of all that is inside it.

Jeanne Carbonetti
END OF THE STREAM
Watercolor on paper,
9 × 8¹/₂" (23 × 22 cm), 1999.
Private collection, Colorado.

At the end of the stage of opening, we begin to notice the stops along the stream with greater urgency. What is in front of us is no longer a passing fancy. There is a greater texture in the stage of closing, for we are now getting closer to our desire.

44

Once the mother-of-pearl begins to coat the bit of matter, the fetus pearl moves freely around the shell. This is actually what creates the round appearance. The little pearl-to-be is free to move and change even now, and it is able to do so only because the shell has closed around it. It can become what it needs to become.

So, too, must we close during this most crucial stage of the creative cycle. As a creator, you either fully engage the piece of life that is going through you, making it one with you and thus making meaning of it, or else the two do not come together and the process is halted, unfulfilled.

Quiet Time

In earlier creative stages, it was important for you, as creator, to be open to many different avenues of inquiry—to explore, play, discuss—all with a rather obvious level of activity. But now, a demonstrated quiet takes over; you are alone with your work. Now it is important that you not have outside influences, for it is imperative that your own essence merge with the material. It is at this stage of creation that many artists put sheets over their canvases, or studios suddenly become off limits. In my own work, I can feel the very moment when I have crossed over from opening to closing. Whereas talking about my work is helpful to me when I begin developing a painting series, I suddenly find that such conversations produce a sinking in my stomach that tells me it is now time to get quiet. The time has come to get to work.

Incubation

Of the two major parts to the stage of closing, the first is incubation. You are not yet at the point of just producing work (which I have come to feel is the easy part). At this point, you just start to focus on what most draws your attention. In my own work, this is when I think of a motif, a theme for a painting series. But the specifics are not yet fully formed. My play is now more directed than in the stage of opening, but it is still play, characterized by a flexibility in the final direction it will take. It becomes rounded out, just like the pearl in the oyster, by this very freedom of movement.

It is important not to be opening yourself or your work to the public now. Let it follow its own direction. Any outside influence, whether positive or not, can be too strong a directional pull, and the power of your own essence is dissipated. So keep it to yourself, your pearl-to-be, where it can grow stronger. Your baby needs protecting, and only you know how to do this. If you wish to create, you must. It is the very purpose of incubation.

Breakthrough

The second part of closing is the breakthrough, and while there often is a particular moment that brings the classic epiphany of insight ("Of course, I see it now!"), more times than not, it is actually a series of mini breakthroughs that will finally give you the full picture. During this concentrated stage, you expend a lot of energy. Ideas are flowing and some forms are now taking shape, but you are still within a relative state of limbo (remember, the pearl must still be free to move). You know you don't yet have the full picture—because you don't yet feel like dancing. But whenever you do get there, you will surely know it, for a tremendous burst of energy will flood your being. It's the way you feel when a difficult decision faces you, then one day, suddenly, you know what you must do. The kaleidoscope has clicked into place, making sense of the picture. I think you will find a correlation between the amount of time it takes to come to breakthrough and the depth you are seeking to uncover. The deeper you go, the more time it takes.

Jeanne Carbonetti
OUT OF THE FOREST
Watercolor on paper,
11 × 11" (28 × 28 cm), 2000.
Collection of the artist.

In the stage of closing, we begin to see our goal in a brighter light. Although we are not yet sure how to get there, now is the time to go after it.

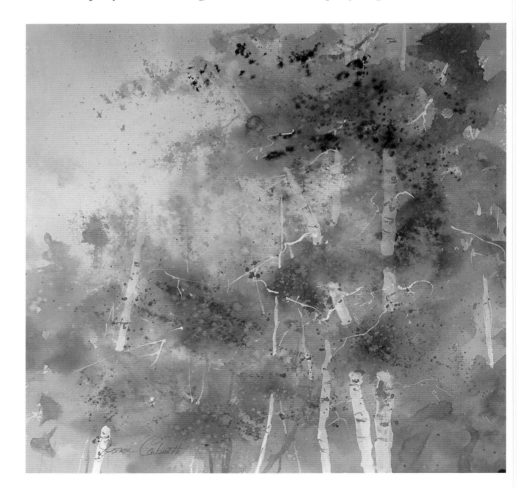

Patience

And of course that takes patience. It is a different kind of patience, however, than needed during the stage of waiting. Now it is the patience of pursuit, requiring a closer concentration. I have wondered if this is the reason so few people really want to be artists on a full-time basis. To create demands regular intervals of solitary quiet, and while that is attractive to most people for a limited time, the fact that it is indeterminate can be oppressive to some. Each of us must move through the cycle of creation guided by our own natural pace and rhythm to make our own kind of pearl.

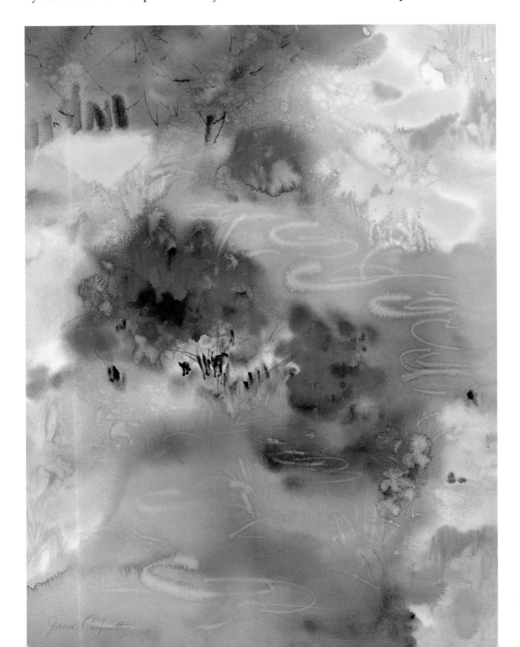

THE IRIS GARDEN
Watercolor on paper,
30 × 22" (76 × 56 cm), 1993.
Collection of the artist.

The stage of closing is at the heart of the creation cycle. We are on full alert as conscious creators, our yellow sun shining brightly on our project.

The Practice of Focus

In today's cyber-paced world, quick thinkers and reactors pride themselves in doing and in producing results. Our culture conditions us to be suspicious of anything that could be called idle. "Do something!" is our creed. While this is an admirable trait and essential to creation, it is not true creation—unless the necessary stage of closing is honored.

Self-Orientation

Closing demands that we learn self-orientation, patience with the process, and an ease with our own boundaries—all characteristics of the practice of focus—to take us deep within to see what's there. Focus thus requires a willpower that affirms our own worthiness to pursue such things. Self-orientation simply means it is important to have time alone, to be free to be receptive to your own thoughts and feelings, your own instinctive urgings— to contemplate, to reflect, without having to form it into communication. You need to commune with yourself.

What you are doing now is producing, beginning the work of creating a form to express your dream. Yet, it is important in this stage that the form still be fluid, not forced—that you let it move and shift directions. While at this stage you are already clear as to your goal (waiting), and you have a good idea of how to get there (opening), now you are in the throes of giving it shape, and the way to do this is to be with it closely to see what it

Jeanne Carbonetti
DAFFODIL AND STREAM
Watercolor on paper,
22 × 30" (56 × 76 cm), 1997.
Collection of the artist.

Every creator must have faith in the stream of life itself, for every creative endeavor is ultimaely our gift to the world.

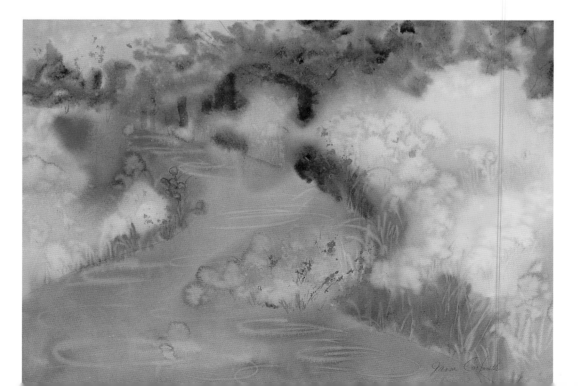

48

Jeanne Carbonetti
**JUNE EVENING,
MAINE COAST**
Watercolor on paper,
7 × 10" (18 × 25 cm), 1999.
Collection of the artist.

*The stage of closing is a time to
pause and reflect on the coming
direction—like watching the
sun's reflection stir a quiet pond.*

wants to become—before sharing it with the world. I read recently that it can be harmful
to expose infants to busy places, that it may overstimulate their very open energy recep-
tors. They need to be kept safe for a time from public display. So, too, baby pearls. You
can't compromise on this; it is the only way energy can find its way into new form as
a conscious creation. In every arena—from making a cake to solving a tough business
problem—to lead a creative life, you must be alone with it, taking time to find your own
rhythm, to make mistakes and to learn from them, to see patterns emerge.

Sacred Space

There are definite energies to different spaces, and they engender different kinds of feel-
ings. My own studio space is quite small, much like a cocoon. It's light and bright, with
red counters, white walls, and a red gas stove that throws out wonderful heat during
Vermont winters. The studio is across my front porch, and my daily commute is a walk
of about eighteen feet. It is a sacred journey. When I am in my studio, I am as far from
laundry and making dinner as if I were eighty miles away from home. Everything there
is imbued with the memory of creating, so even when I am uninspired, I go there and sit,
and after a while, something may stir. I consider it my obligation to be there, that is all.
There are no directives to produce something, or worse, to produce something "worth-
while." My job is just to put myself in the place where creation can come through me,
where I can hear an inner voice or see an image float across my mind, taking me on the
spiral path down to my own core—to the place where all things are possible.

49

Devotional Time

Are you good at closing? Are you disciplined in giving yourself the kind of devotional time it takes to become your creative self? To assimilate this creation stage into your life rhythm, set aside a period of time to contemplate closing. Make a space for yourself, then give yourself permission to take time to do in it whatever moves you most. It need not be a lot of time, but a key seems to be some regularity of schedule, such as Sunday afternoons, or Tuesday and Thursday evenings, or one hour each night. Start as small as you need to, so that your practice is a delight and not a chore. This is a life habit you are creating; you need not force it. As you begin to honor the act and art of closing, you will feel a difference in the way you live your life. You are now in the heart of creative living. You now honor the periods of waiting in your life, when you are patient and watching for signs. You are open and attentive to new things and new ways that excite you as you play at the most important game of all: making a pearl of your life.

Jeanne Carbonetti
SUMMER BIRCHES
Watercolor on paper,
35 × 22" (89 × 56 cm), 2000.
Collection of the artist.

Every time we accept the challenge to create something new, whether in art or in any realm of life, we begin the hero's journey into the forest of our deeper self.

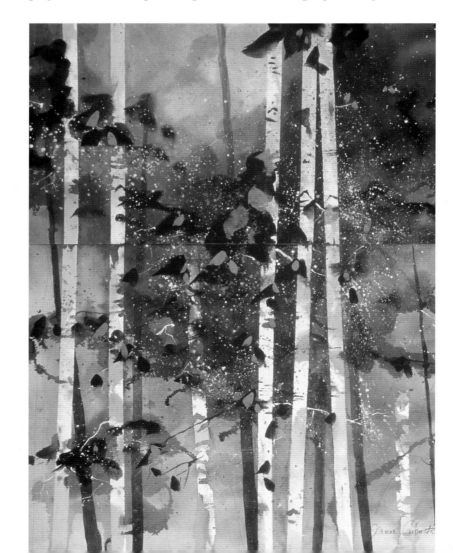

The Gift of Commitment

The stage of closing is a gift of commitment. It provides us with the best channel for the energy of our wills, allowing our willpower to be servant and protector of something that is so worthwhile to us that it moves us now to produce. We are at the height of the creative cycle. The will to produce is raised to the level of commitment, focused with powerful attention. Our goal, our dream is taking shape. Everything in us begins to coalesce to produce and protect our dream while it grows. We are now grounded enough from the stage of waiting and enthusiastic enough from the stage of opening that we have the willpower to commit ourselves to this new birth.

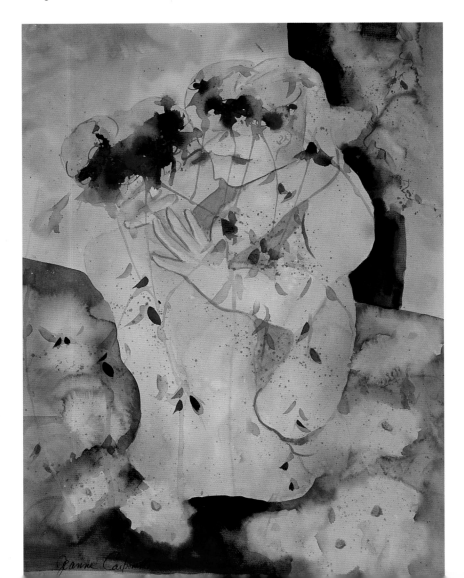

Jeanne Carbonetti
STUDY FOR THE KAMA SUTRA
Watercolor on paper,
30 × 22" (76 × 56 cm), 2000.
Collection of the artist.

Like lovers for whom the world is closed out except for each other, creators see only their desire in this stage. We steep ourselves in it now. We may try different methods of achieving our goal, but now there is a commitment to outcome. The goal is no longer an issue—only how to get there, and when.

The Power of Art: Creation Cycle, Part III

A Symbol for Closing

As you might guess, the symbol most precious to me for the theme of closing is the oyster shell. I have a number of them. As a practicing artist, I know that the stage of closing, when I pull into my own shell, is crucial to making works that are truly from the core of me. I also know how much willpower it takes to do this when there isn't approval from the world that your time is well spent. When you are in the laboratory of focus, you are often not making money or whatever commodity your world finds useful. At least not for the moment. You must have the strength of your own will and a faith that in being your most creative self, you will be helping those around you. As you draw from the well of your own creative spirit, you will have more to give, and more strength to give it.

Find your symbol for the beauty of closing. If it is small enough, carry it with you. If it's larger, put it where you'll see it daily, reminding you to honor the practice of closing, making this aspect of the creative cycle a natural part of your rhythm.

Continue with your art project by coloring in a seven-inch square with shades of yellow, a color associated with power and presence on the physical level. Put any words, images, or symbols on this square that speak to you of the stage of closing: its patience, quiet time, breakthrough, willpower. Perhaps now you are moved to go back to previous squares, tying them together, adding, or even subtracting. This is what this stage is all about. It is your form. Let it be you, without apology.

Example, background only: *A field of yellow watercolor provides the base for the third part of our creation-cycle exercise.*

Example, completed square: *Randi Dunvan mixes collage, watercolor, and words that symbolize closing for her.*

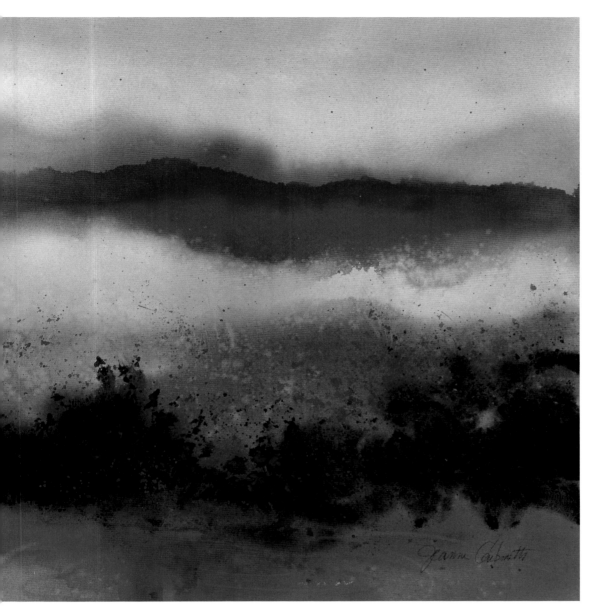

CLOSING TO STRENGTHEN YOUR LIGHT

Allow yourself fifteen minutes of solitary, uninterrupted time.

Close your eyes and take three deep breaths, letting go of tensions in your body, mind, and spirit.

Imagine a ball of clear yellow light. Let this soft fog of color move across your abdomen, the seat of your will. Let it light your solar plexus, then let its light, like rays of sun, beam outward.

Each time you need to strengthen your will, picture it there, reminding you that you have the strength to be who you are—and that is good for the whole.

Jeanne Carbonetti
TUSCAN MEADOW
Watercolor on paper, 22 × 22" (56 × 56 cm), 1999.
Collection of the artist.

Although we may feel our goal still to be in the distance, we begin to sense that we know how to get there. Our productivity becomes general and evenly paced in the stage of closing. We know where we are; we know where we're going.

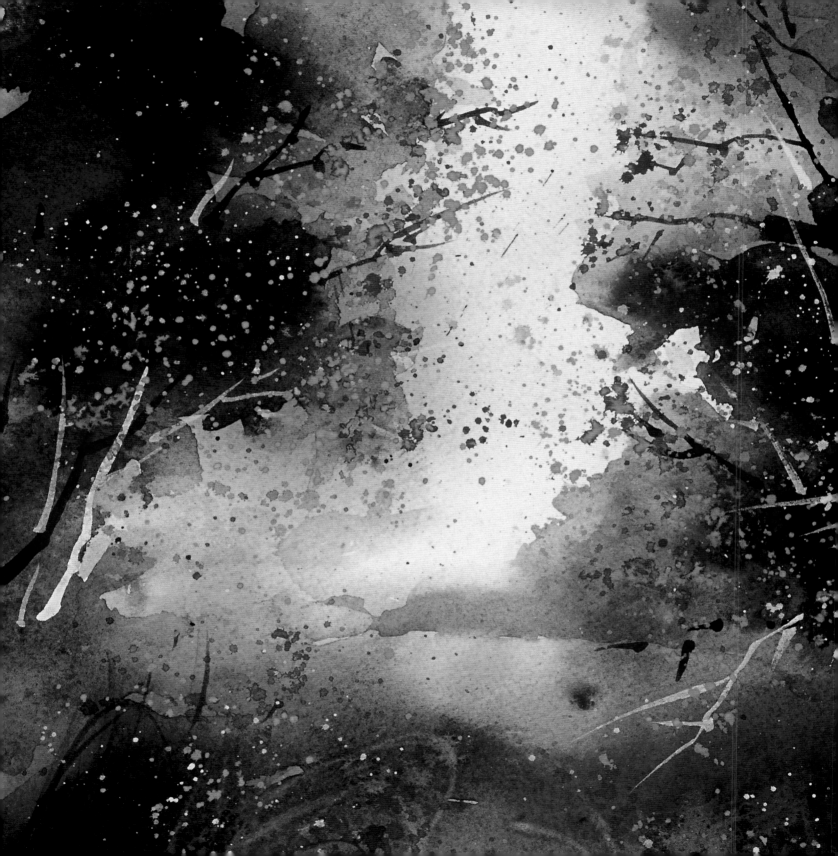

4

Holding

Perhaps all the dragons in our lives are
princesses who are only waiting to see us act,
just once, with beauty and courage.

Rainer Maria Rilke

Jeanne Carbonetti
A CLEAR VIEW
Watercolor on paper,
9 × 8" (23 × 21 cm), 2000.
Collection of Thelma and Tom Muzik.

*The beauty of the stage of holding is that
when we hang on long enough, the path
becomes clear. But an important prereq-
uisite for the creation journey is that we
must be willing to spend time holding on
to our dream when the path is not clear.*

The Nature of Holding

Facing our dragons is what holding is all about, and the way to face our dragons is with beauty and courage—with a faith in the worthiness of our efforts, no matter what, and a will to continue, despite obstacles.

For the oyster in this stage of pearl-making, the irritation of sand or other foreign matter that got lodged inside his shell has almost become a pearl. After all this time, that thing is still rolling around, still causing some trouble, and it would be nice to be able to just open up wider and spit it out. But the oyster can't. He knows he has to stay closed enough (focused enough) to continue filtering and digesting his food. It is a matter of survival. His nourishment hinges on "hanging in there" and continuing his chores.

So, too, with us. In the stage of holding, artists can learn from their more linear, goal-directed, systems-oriented brothers, for it is a sheer determination and willingness to do the tedious chores in order to produce that is a valuable asset now. I believe it is this ability above all others that allows some artists to make their life into their livelihood, while others, who are equally gifted, never really develop a body of work. They may create wonderful pieces here and there, among their flitting to other things, but a deeper dimension to their work, a true evolution from this middle stage, never gets to take place, because holding, in creator terms, means persevering. It is a conscious decision to stay with it and keep at it. It requires faith, equanimity, concentration, and imagination in the face of such dragons as boredom, uncertainty, and tension. Boredom can be an especially big issue for creators, because it can push you to move to another idea before you've held on long enough to the present one to give it a chance to assert itself. In my own work, I am always aware that the theme for my next series of paintings shows itself somewhere in the middle of my present one. I have to put that intruder away, seductive as it might be, until its proper time has come. Instead, I must work at holding to the job at hand.

Faith

Holding of faith means holding when there is still not much to show for one's efforts. The dragon of uncertainty may make you fear that no one will like your work, so why put forth the effort? Why work that hard for a dream? The dragon of uncertainty must be told firmly, "Yes, I will. I am committed."

Having faith in oneself is not self-promotion or hubris. It is a wisdom that knows that when any heart fully expresses itself honestly, it is on the deepest level a benefit to society. We are made as unique creators designed to make creations in every sphere as unique as we are. The universe is capable of holding our differences. We must have the faith to let ourselves be ourselves, doing what we do. Only then can the whole be served.

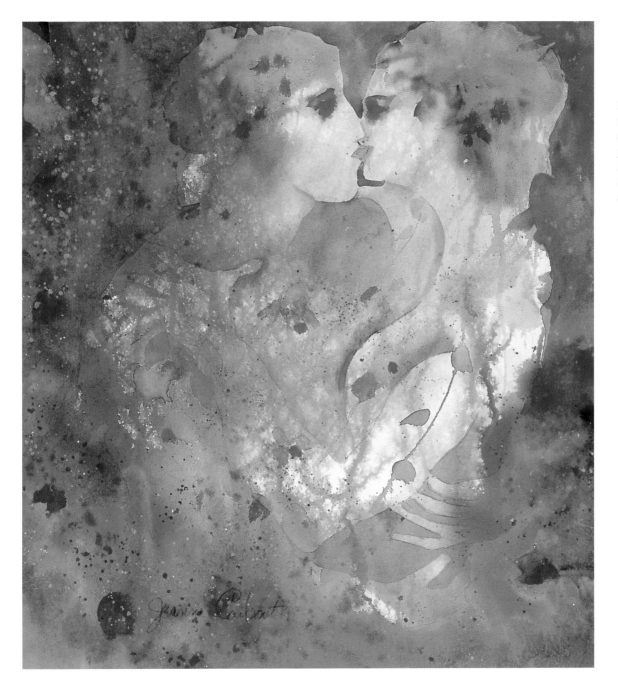

Jeanne Carbonetti
EROS
Watercolor on paper,
25 × 22" (64 × 56 cm), 2000.
Collection of the artist.

In all creation, there is a marriage of polarities—of spirit and form, of yin and yang, of female and male. It is a synthesis that is born of paradox, and out of it comes true Eros.

The dragon of tension is perhaps the most awesome one of all, because the tension is usually one of opposites trying to be reconciled by your work. In fact, I believe all true creation is an act of reconciling polarities. At the heart of being human is our natural instinct to unite opposites, to create union: male and female, Heaven and Earth, the individual and the collective, the microcosm and the macrocosm. If there were no polarities, there would be no real choice, no free will. And where there is no choice, there is no creation. Now is the time to have faith in our choices.

Concentration

Aside from being willing to do the chores of our work and having faith in the value of our work, we also need the power of concentration—a focused attention, not unlike that experienced in meditation. When you are trying to create anything, you need to be able to hold it in your consciousness long enough to let it speak to you. Thus, you need drive as well as receptivity. Perseverance has the masculine, yang nature of this assertiveness. Concentration has the feminine, yin nature of allowing yourself to be receptive through the focus of attention. Perseverance is an act of will; concentration, an act of intuition. Together, they strengthen the art of holding.

Equanimity

There is also a more subtle and powerful aspect of holding: the quality of equanimous self-knowledge. In the stage of holding, we face the mirror of the self. With unflinching fortitude, we see our strengths and weaknesses, learn to accept them, and to keep going.

But even more, as you enter deeply into the creative cycle, if you stop yourself, it is important to see where. It is one of nature's laws that if creation is being aborted somehow, it is more often being cut off by the creator, not by the outside world. An awesome responsibility, but it comes with the privilege of creatorship. We mold life as we will, and sometimes we stop ourselves. When we do, we need to ask why—and love ourselves anyway.

You must love your dream enough. That is why, in the earlier stage of opening, it is so important to ascertain what excites you, because if you cherish it enough, it will always be valuable to you. In my own experience, I created a painting that I considered to be my masterpiece—one that I felt truly mirrors the core of me. After I completed the picture, which I called *Water with Lilies*, and made prints of it, a full two years went by before anyone so much as looked at it. Yet, I was at ease with its being ignored, whereas I have not felt that way with other works of mine that do not receive notice. With my cherished painting, however, it didn't matter at all, because I believed in it and loved it so. I have always remembered that experience, for it taught me to be sure I am doing my work for my sake. Only then will I be committed enough to see it through.

Imagination

Finally, the stage of holding is the perseverance to use your imagination to hold to your dream, whatever it is, even when the way grows muddy or seems out of reach. It is about continuing to picture your dream, foggy though it may be, and to be patient that its time will come. In watching art students, I have learned that it is common to give up on paintings far too soon. Often the creation is trashed just before it might have reached its brilliant breakthrough. We must persevere with our creations. A dear friend of mine is a deep well of patience. For years, he held in his heart the dream of a true love, but never tried to force it to happen. Then one day, his love appeared—literally, on his doorstep—and the pieces of destiny fell into place in a breathtaking way. One must be patient with one's dreams.

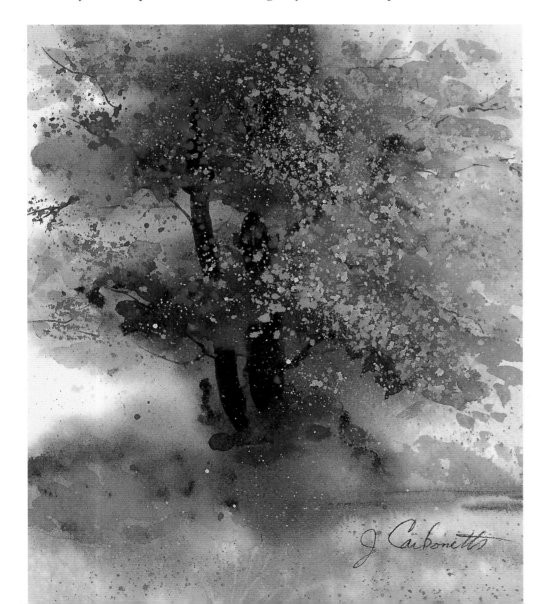

Jeanne Carbonetti
TREE BY THE MILL
Watercolor on paper,
9 1/2 × 8 1/2" (24 × 22 cm), 2000.
Collection of the artist.

In the Zen tradition, it is said that when one opens the heart, one develops a green thumb. Likewise, in Hindu and Buddhist traditions, the symbolic color of the heart is green, for it represents the heart's ability to grow and to nurture. In the stage of holding, we learn to nurture our own growth process, loving ourselves enough that we can let our buds bloom.

The Practice of Pulsing

Jeanne Carbonetti
WALKING ON WATER
Watercolor on paper,
23 × 10" (59 × 26 cm), 2000.
Collection of the artist.

In the stage of holding, we must be gentle with our dream. Never force it; be present to what is.

We need to recognize the beauty of our own natural process, our very personal rhythm, and we need to trust it. We must also recognize our dragon, the place in us that always tries to block our good, that tries to make us feel unworthy, and we need to *take heart*, to face this part of us with equanimity, allowing it to teach us. The truth is that we are both prince or princess *and* dragon, each one of us, and bringing them together within us is the way we release our most potent creative power.

So how does one take heart with each of the dragons that face us? *Pulsing* means letting go of concentration and knowing when to relax so that your rhythm is restored. Especially if you are very strong in perseverance and concentration (as I am), where nothing distracts you from your goal, even though you may still be "playing" when working with an idea, you can go too far. If you listen too closely and persevere too diligently, treat yourself to a break.

Balanced Rhythm

Pulsing during this stage of holding will allow you to get your rhythm back. It is called for when one part of your consciousness tries to take over and doesn't let the other parts speak. In every creation, the three consciousnesses, Logical Mind, Body Mind, and Heart Mind, need to be represented. The act of pulsing—of stopping, then restarting—helps them dance with one another again. One way of pulsing is to make a schedule that is truly in tune with your own rhythm, but allows for flexibility. In my work, for example, I wear three different hats—as studio painter, gallery owner, and teacher. All of them require schedules that are subject to change. I divide my day into a morning and an afternoon session, which fits my biorhythm best, and days of the week for different tasks. Even though there are times when one part of my work overrides another, there is still some allotment for all three, so my general rhythm remains constant.

Reachable Goals

Another way of pulsing is by setting goals that are attainable. In my case, I have a goal of two finished paintings per week—not great paintings, not even good paintings necessarily—just pieces of work. If I have done that, I have fulfilled my obligation as a studio painter, and I have given myself the opportunity to grow. My job is to be there, keeping at it, that is all. It is a humble goal. Yet, I have found that its simplicity actually makes it a reachable goal, despite the changes intrinsic in daily life, and it keeps me connected to my goal at all times.

The dragon that may interrupt connection to a goal is fear—fear that one is not going to produce something worthwhile. To banish that dragon, I treat every painting as an experiment. This takes all the pressure off and encourages me to try outlandish things. That, in turn, encourages the "deep play" that carries me away with it. A friend of mine, a very kinesthetic artist, has learned that curiosity takes over as soon as she begins playing with collage. Fear used to be a big issue for her, but that dragon has now been tamed. However, sometimes pulsing means stopping altogether for awhile. At such times, instead of painting, I read, and since my instinct always guides me to written material that will directly aid my visual work, I soon become inspired again.

Affirmation

Finally, the art of pulsing is empowered through the skills of visualization and affirmation—to spend time allowing yourself within the secret laboratory of your imagination to develop what you most resonate with, both in picture and words. Notice how you feel as you picture your goal; notice if your words uplift you just to speak them. When you feel the power of them, you will trust the miracle of your own creative power.

The skills of visualization and affirmation are greatly enhanced by the practice of meditation, as demonstrated in mediation exercises recommended in earlier chapters of this book, and those ahead in remaining chapters. Meditation facilitates a quieting of the

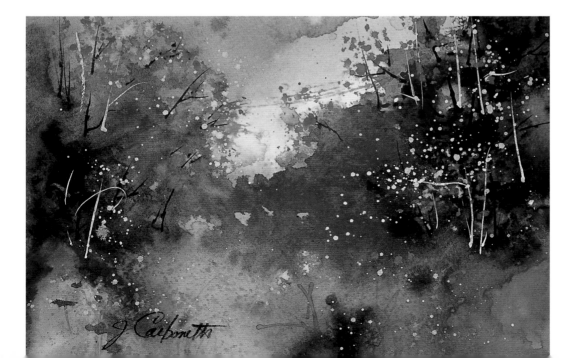

Jeanne Carbonetti
SPRING TREES
Watercolor on paper,
9 × 12" (23 × 31 cm), 2000.
Private collection, New Mexico.

Like trees in early spring, though not fully formed, our vision is a gift we must nurture and hold lightly, tenderly.

mind, so that deeper levels of consciousness can be reached. The benefits of meditation are many, ranging from the physical to the metaphysical. As with every other skill that develops the art of holding, meditation methods should be adapted to your own needs and natural rhythms.

Finally, if the stage of closing is the most crucial to the making of a pearl, the stage of holding is the one that allows the pearl to become all that it can be. Know that your dream is coming true, even if it doesn't seem so. That is the true art of holding.

Jeanne Carbonetti
SUMMER GREENS
Watercolor on paper,
7 × 14" (17 × 36 cm), 2000.
Collection of Wyn Kalagian.

When we can't quite see the forest for the trees but stay with it anyway—that is the stage of holding. It is a time for equanimity, for seeing the ups and downs of our creation and ourselves as creators, and not running away, but holding on, no matter what.

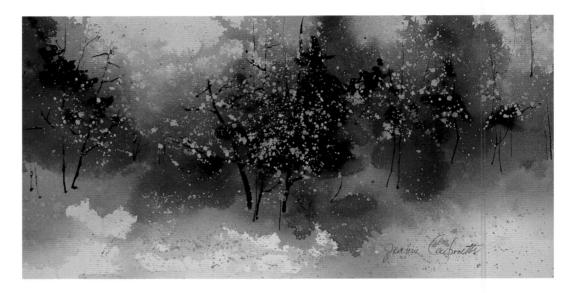

Jeanne Carbonetti
LIGHT ON THE FOREST FLOOR
Watercolor on paper,
14 × 14" (36 × 36 cm), 2000.
Collection of the artist.

If we hold on long enough and gently enough, we will see the light. But we must be alert to all the signs, for they may be timid at first. Just when you think it is time to give up, hold on a bit longer, for that is the time when signs appear.

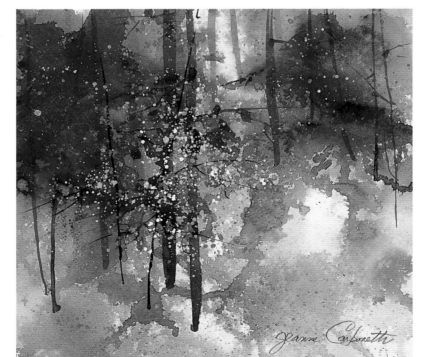

The Gift of Compassion

The beautiful gift of the stage of holding, if we allow ourselves to receive it, is compassion for all the parts of ourselves. We can't help but see all the parts in this stage, for the laser-like focus of our efforts can't help but shine a light on them. If we are to continue on to the fruition of our dream, we will surely face them, and we must not run away when they appear. Instead, we pulse as boredom and tedium set in; we gently continue even as fear tries to stop us; we hold on to our dream, even as others try to distract us or defuse our energy. In the stage of holding, we see all our vices and shortcomings, the limits of our creation, but we love it anyway and simply keep going.

The gift of compassion enables us to appreciate the complexities of the creative process. We may face procrastination and realize that it is signaling to us the need for a change in direction rather than just bulldozing and plodding our way through our original intention. We may face boredom and allow it its space, recognizing that our original dream is still present, just weary. We give ourselves a needed break and then continue, ready to look for the deeper signals.

This allows us to appreciate the same complexity in others, recognizing that the cycle of creative life in them is offering the same challenges it offers us. Thus, the gift of compassion teaches us to find the pearls in others.

At the height of the cycle, in the stage of holding, we hold on to all the parts equally and without judgment. We just keep responding to the issue at hand, which keeps us close to our core. It is the true heart of the cycle, and its gift is love.

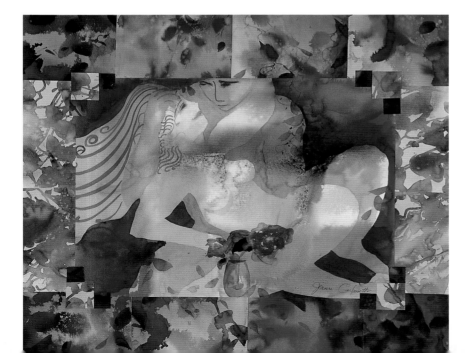

Jeanne Carbonetti
EURYDICE'S DREAM
Watercolor and collage,
36 × 40" (92 × 101 cm), 2000.
Collection of William Herp and
Caroline Polurde.

If we, like Orpheus, can just trust enough in ourselves and in life, we can bring our dreams forward into the light. Eurydice knows that one day we will.

The Power of Art: Creation Cycle, Part IV

Following the same directions as earlier (page 29), create a square with a background of green, which is a universally symbolic color of nurturing and growth. Add to this square words, symbols, or whatever other elements represent the stage of holding for you. Is it holding with nonjudgment? Is it the practice of pulsing? Is it compassion? Which is most important to you in your own journey? Now, move back and forth among the squares you have already created, to see how they relate to each other.

A Symbol for Holding

The fourth stage of the creative cycle is the heart center, its energy a gentle, constant pulsing, holding us and our creations in a rhythmic bond. Listening to your heartbeat can keep you in present time, true to yourself as a creator. The heart is where the answer of truth lies, for Heart Mind is the synthesis of Logical Mind and Body Mind.

In my workshops, I teach that technique, vision, and love are like sections of a pyramid. Technique is a small section at the top, powered by personal vision, the section just beneath it. But the largest part, the base of the pyramid, is love—the unconditional love we give ourselves that lets us experiment, fail, and try again, out of which beautiful creations in every realm can come. If you wish to be a better creator, you must love yourself more.

The heart has been my symbol for this powerful stage in the cycle of creation for many years. My woods seem to give me gifts of heart rocks all the time. I have quite a number now, and they always come at just the time I need them most. It is my most potent reminder that love is the only true foundation of any creation. What is yours?

Example, background only:
I gave full coverage to my green square, but background choices may vary greatly, and more than one shade of green may be used.

Example, completed square:
Andy Swenson chose a few different greens and blue greens for his background. Then he added collage and key words to symbolize the stage of holding as he sees it.

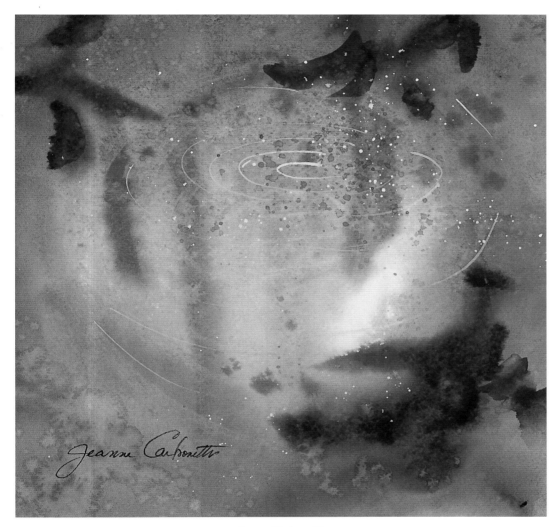

Jeanne Carbonetti
MANDALA
Watercolor on paper, 15 × 15" (53 × 53 cm), 2000.
Collection of the artist.

*Like bright light cast by a full moon, meditation can illuminate your
way to a state of hyper-awareness, letting you see deeply as well as
broadly—and by the end of the stage of holding, you will have a clear
sense of the direction your creation is taking.*

Meditation

HOLDING WITH LOVE

*Sit in a comfortable position
with your spine straight,
and spend ten minutes just
noticing your breath.*

*Close your eyes. Using
your imagination, allow a
personal quality you dislike
within your creative life to
present itself in symbolic
form—as though you were
watching a beloved child have
a tantrum before going to
bed. You know he just has to
get it out of his system, and
you know it will pass. Hold it
with the notion that it might
possibly be the shadow side
of a virtue in you.*

*Now, with your mind's
eye, see your dream written
in words. Play with it until
the very words themselves
make you feel good just to
see them. You will know you
have touched truth. Picture
and feel your dream, as
fully as possible. Enjoy it.
Do this often.*

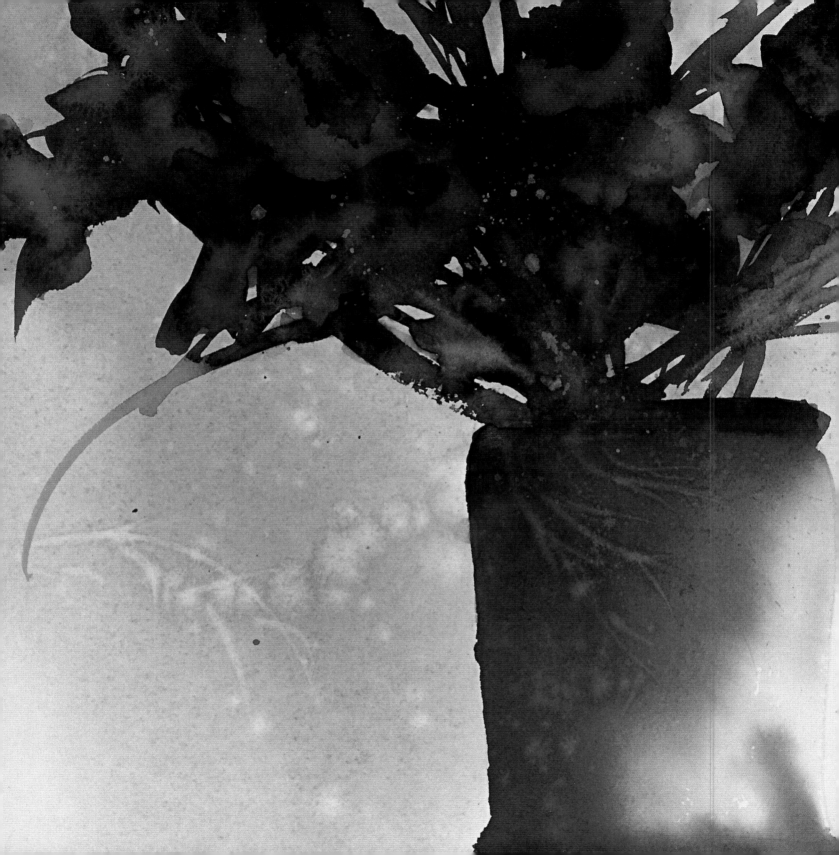

5
Releasing

Let it be.

Paul McCartney

Jeanne Carbonetti
JAPANESE IRIS
Watercolor on paper,
22 × 15" (56 × 38 cm), 2000.
Collection of Debra Irons.

In the stage of releasing, we let our
creation become what it needs to be.
A synergy that develops is bigger than
our desire to control. This is the threshold
of mystery, when individual will meets
divine will, and the two become one.

The Nature of Releasing

The day comes when the pearl is as big as it is meant to be. The shell's mother-of-pearl lining has created something out of that once irritating sand particle, but the oyster keeps working at it, even when it is time for the pearl to leave the shell.

It is not within our human nature, either, to give up things easily. As creators, we invest so much energy in the building-up phase of our creative cycle that we may fail to notice when the time has come for the downward phase to begin. We tend to dislike this part of the cycle. We tell ourselves, as Vincent Van Gogh did, that we're not good enough yet; or we overwork, as did Henry James, with yet one more revision before it's done (his manuscripts had to be stolen from him to get them to his editor); or we leave our creation undone so we can postpone the inevitable: that our creation must one day leave the shell, live on its own, and risk being judged.

Give, Forgive

So where once we were meant to receive, to nurture, to hold, now we must reverse the process and give. Releasing is when we come to terms with all that our creation is, and what it isn't, and then we give it to the world. For all of this, we need the art of forgiveness—for ourselves, for our creation. In this stage, we allow our creation and the process to follow its natural course. Chances are it has changed somewhat from the original intention. In the stage of releasing, there is a surrender to what has already been put into motion. It is what it is.

I feel this distinctly whenever I complete a painting. I might begin with a landscape scene in mind, but soon, the paint, water, and paper come together in an unexpected way and I begin the stages of closing and holding as I simply respond to the dynamic balance of each new stroke. It is alive, because it takes on its own life and every stroke is a living response to a real issue. When I let my painting become what it wants to become, I let the true nature of my creation shine through. My landscape will always remain a landscape, but it will then show me, because of my willingness to release its boundaries, an aspect of that landscape that I had not seen with my outer eyes, but with the inner one, and most often it is a revelation.

Accept

Giving over also means allowing your work to stand on its own. There comes a time when you must let it be out there for the world to see, for some to love it, for others not to love it. No apology. Many wonderful creations are aborted at this stage, because their

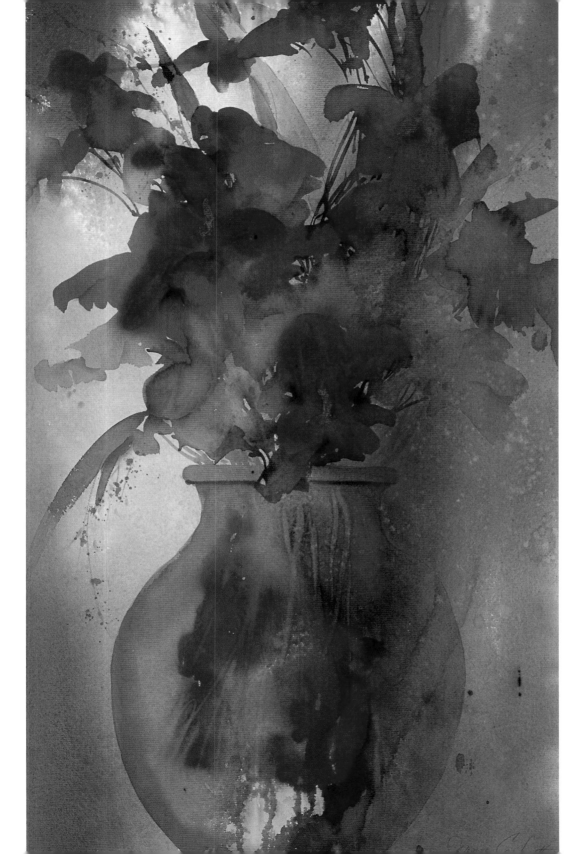

Jeanne Carbonetti
**EVENING LIGHT
ON LILIES**
Watercolor on paper,
30 × 20" (76 × 56 cm), 1999.
Collection of the artist.

*Creation is what humans are
programmed to do. It seems
necessary to the organism, for
the energy of bringing something
into the light pulls all our forces
together in synchronicity.*

creators fear rejection. But releasing means accepting that your job is getting it out there, not making the world love it with you. The history of art and science is a continuous story of first rejection, then acceptance, then finally, celebration of creative energies ahead of their time. That is because creative energy is *beyond* time. It is the culmination of our multiple consciousness, which is itself multidimensional.

Conclude

Releasing is also the act of preparing to withdraw your energy from something. It is an act of concluding. Here, even giving up is a creative act, for you are pulling open the shell of yourself and retrieving the pearl. You have realized that this pearl is no longer something that moves you; it has grown too far astray from your first intention and now is something wholly different. This is the creative "no," and it can be as constructive as the creative "yes." This is not the voice of the inner critic, that nagging voice that keeps us from feeling inner quiet and resolve. No, the voice that speaks now is not excited, harsh, or hurried. It is the firm but soft voice within, the one in touch with wisdom that says quietly, "It is done."

Releasing takes its different forms, from surrendering to a different vision or rhythm, to letting go of fears about facing the world, to a final letting go completely. In all of them we accept the natural rhythm of the great creative law: There is a time for every season under Heaven.

Jeanne Carbonetti
BELOW LEFT:
SILENCE
Watercolor on paper,
16 × 15" (41 × 38 cm), 2000.
Collection of the artist.

By the time we get to the stage of releasing, we silently accept our vision in the shape it now takes, letting it emerge for what it is— not what we first hoped it would be.

BELOW RIGHT:
SPRING BIRCHES
Watercolor on paper,
13 × 15" (33 × 38 cm), 2000.
Collection of the artist.

When do we send our creation out into the world? When we see it clearly. Then it and we are ready.

Jeanne Carbonetti
SPRING EVENING ON ECHO LAKE
Watercolor on paper, 12 × 14" (35 × 30 cm), 1999.
Collection of the artist.

*Releasing sometimes comes quietly and unobtrusively. Some creations feel
so natural, they seem to emerge on their own—a sure sign of true balance
and flow.*

The Practice of Surrender

When we come to terms with the fruition of a dream, we have reached the practice of surrender. In the best circumstances, releasing takes on the feeling of autumn ripeness, where the fruits of our labor are abundant and there is a cornucopia of gifts we gladly present to the world. Too often, though, we either hold on too long and move too slowly through this stage, or we are impatient with its more mundane tasks, so we jump to another project, another dream. But the slowing-down part of the creative cycle is just as important as building momentum during earlier stages. The act of surrender is allowing yourself to receive the gifts of this stage, to shift your energy from dynamic assertion to the more narrow scope of presentation. You have been preparing for this for some time. It is time to put it out there.

Facing Truth

The actual act of surrender begins when we ask the question, "What is the truth of this?" This question moves you from the role of actor to the role of witness, and important learning can take place. No matter what the project, plan, or dream, every act of creation teaches you about yourself as creator. Those who face the truth of what worked and what didn't work are the creators who will grow better at creating—particularly those who work in the creative arts. When an individual piece does not go well, the artist is often frustrated into giving up, or perhaps starting again at a later time. But a valuable opportunity for sharpening one's skills is lost in this approach. If we accept that some aspect of the truth of our vision is present in this piece, we can more easily accept the clarification it gives us.

My own "Rejection/Resurrection" drawer is invaluable here for gleaning the truth of where I've been, where I am, and where I'm going. As I begin the process of slowing down, stepping back, and choosing paintings that will create a show, I look back at pieces that didn't work. Perhaps now I know what to do, and that shows me how I have grown as a painter. Other times I catch the thread of a new direction, a glimmer of inspiration for the future. Most of all, I am always reminded of the cycle of creative endeavor, and how this cycle widens, like ripples on the water, to enlarge my vision of myself.

Our soul, so much bigger than our ego, wants us to grow into an awareness of itself. This is the purpose of all creative process, and the journey of every human life. We are meant to know ourselves as creators. We are meant to know the truth. In the stage of releasing, we have the courage to ask.

Handling the Mundane

Practicing the art of surrender also entails honoring the more mundane aspects of our work. "After bliss, chop wood," goes a Zen adage. We may have created a beautiful baby, but unless we are also willing to take care of the baby's diapers, we have overlooked something. If we are unwilling to take care of the details, something in us doesn't want it enough. To make our dream real, we must take care of the ordinary business that bringing it to fruition demands.

In my own work—an artist seeking to make my living through art—I know how polarized the two energies of abstract creativity and concrete presentation can be. But as a gallery owner and teacher as well as a painter, I must constantly find a balance that allows the business at hand to get done, so I often adjust my schedule to accommodate needed energies for each task. For example, I have resolved that I never do paperwork on studio days. Another self-imposed rule is that big jobs require big time; little job, little time. The tasks of Heaven may seem much more ecstatic than the ordinary chores of Earth, but they are really one, and we must honor both.

Jeanne Carbonetti
**HUMAN HEART,
BUDDHA SOUL**
Watercolor on paper,
22 × 30" (56 × 76 cm), 2000.
Collection of the artist.

*Art always speaks the truth,
for it is the perfect mirror of the
soul. In making art, you can find
where you are.*

Breaking Momentum

When it's time to surrender to the slowing-down phase of the cycle, time and distance become ways of initiating the shift. Changing pace acts somewhat like a ritual in that it breaks the momentum you are used to, formalizing the change. It can be as simple as taking two days off and going somewhere else. But it's important that you make the shift consciously, with a recognition that you are summing up one phase and moving to another. I do it by giving myself deadlines for all my work, but then I'm very playful with them and feel no compunction about moving them back, so they serve then as a kind of punctuation of my day, week, or month.

Overcoming Obstacles

Finally, the biggest surrender is to the larger purpose behind all of it—to the destiny you are seeking to fulfill through your endeavors. It means understanding that just because you know how the process works, it's not necessarily going to be easy. Even the great masters Michelangelo and Leonardo da Vinci worked tirelessly to learn and grow. Neither was afraid to experiment and make mistakes. Late in his life, Michelangelo said, "I am still learning." Leonardo said, "Obstacles do not bend me." They must not bend us either—and that is a choice we make.

Jeanne Carbonetti
CLEAR CUT STILL LIFE
Watercolor on paper,
15 × 22" (38 × 56 cm), 2000.
Collection of the artist.

Now and then, everything seems so clear and clean. We're so sure about our creation, we put it out into the world without any self-doubt. Let's enjoy such moments!

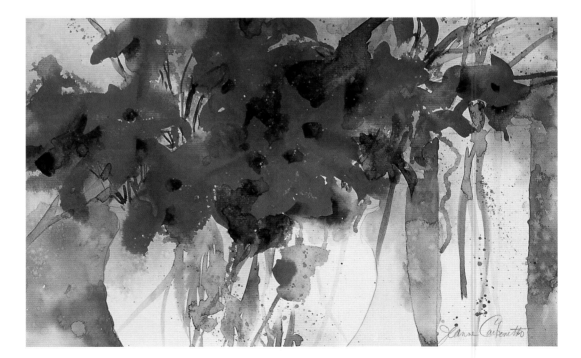

The Gift of Truth

The spiritual gift we receive from the stage of releasing is the truth of who we are. We have seen it in the process and we express it as we give it to the world. Like the bird that sings because that's what birds do, or the grass that grows no matter how much we mow it, because that's what grass does, we are creators who are born to dream and to shape our desires into a form that can be expressed. We live the dream, we present the gift, we achieve our goal. In whatever way we choose to do it, we do what we were made to do: speak the truth of life as it presents itself through us. We have fulfilled our obligation as humans. We have created.

Jeanne Carbonetti
KILLINGTON SHADOWS
Watercolor on paper,
25 × 22" (64 × 26 cm), 2000.
Collection of the artist.

While it is beautiful at the top of the mountain, skiers know there is a thrill in coming down again, of letting go, of releasing.

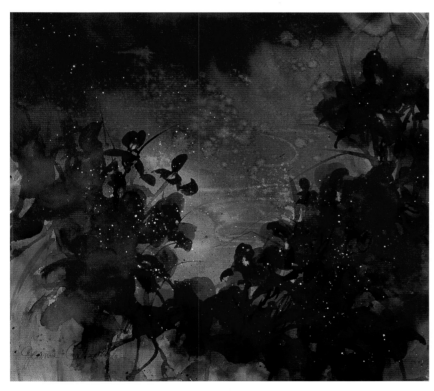

Jeanne Carbonetti
IRIS AND POND
Watercolor on paper, 22 × 22" (56 × 56 cm), 1999.
Private collection, Illinois.

When what we create comes from our heart's desire, we must let it flower, giving to the world the gift that grew from a seed nature planted in us.

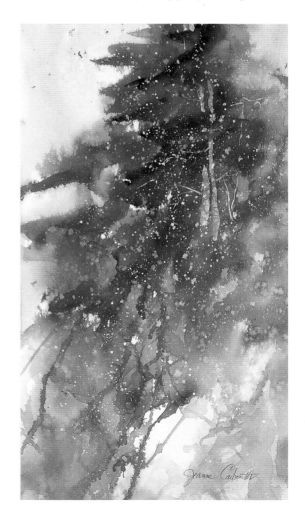

The Power of Art: Creation Cycle, Part V

Following the earlier directions (page 29), create a square with a background in shades of blue—the color of the throat center in the Hindu Chakra system and the symbolic color for expressing truth. Fill in the square with whatever words, symbols, or images are most meaningful to you, related to the stage of releasing. You might want to work in another medium, different from that used on your earlier squares.

A Symbol for Releasing

My greatest satisfaction comes from expressing truth—cleanly, clearly, fully. It doesn't matter if it is in words, images, or an action— as long as it comes from my heart, I need to express it, and I never regret it.

My most powerful symbol of releasing is Water with Lilies, *a painting I made a few years ago. I feel that painting is me, all of me, and every day it reminds me of the beauty of being fully myself. I am awed by it and the power it has upon me. I painted truth in that work, and ever since, when I look at it, I remember who I am.*

What symbol means releasing to you? As you move through your day, notice if something calls to you for expression. If it feels forced, perhaps something needs to be surrendered to the larger good. The great beauty of the releasing stage is that it was formed in and through us and is now ready to move out of us, into the world.

Example, background only: *My blue square flows in a circular pattern, just one of an infinite number of ways to prepare a background for this exercise.*

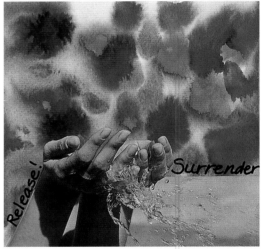

Example, completed square: *Artist Laurie Marsh made a ground of watercolor splotches in a range of blues, then added collage and two words that sum up this stage of the creation cycle.*

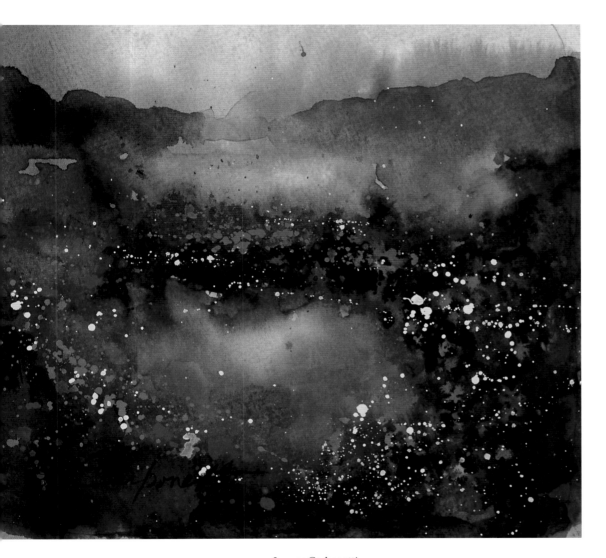

Meditation

RELEASING FOR TRUTH
Allow yourself a quiet place and time.

Take a few deep breaths and let thought go. Settle into your body.

Concentrate on your throat center. Notice any sensation there. Allow whatever comes to simply be, without judging it.

Allow a cloud of blue to permeate your throat center. Notice its color. It might be strong or pale, clear or muddy. Let your awareness be with it, taking it in.

When it seems appropriate, ask it, "What is the truth you wish to express?"

Let your throat speak in its own way and in its own time.

Jeanne Carbonetti
ANNIE'S MEADOW
Watercolor on paper, 7 × 8" (18 × 20 cm), 2000. Collection of the artist.

There is a lovely feeling that comes when one brings the dream to fruition.
It is a testament to all your work, both within and without.

77

6

Emptying

He who binds to himself a joy
Doth the winged life destroy.
But he who kisses it as it flies
Lives in eternity's sunrise.

William Blake

Jeanne Carbonetti
WISTERIA
Watercolor on paper,
30 × 22" (76 × 56 cm), 1999.
Collection of the artist.

*When one has been in flow with the
creative cycle, allowing each stage to be
what it is, then the stage of emptying is
characterized by a feeling of fullness. It
is a lovely paradox.*

The Nature of Emptying

An open but empty bivalve shell floats up on the beach. Farther away, a pile of half shells, their partners missing, wait to be thrown away. In both cases, the pearl is gone, and the oyster shell is emptied of the life to which it gave itself. Pearl-making is done.

This end to creation may seem like a death. In some cases, it is a more natural death, as when the bivalve has both parts of itself intact. Other times, it is an unnatural death, when the half-shell is pried apart from its mate. Both kinds of death are integral aspects of the stage in the creative cycle known as emptying.

The nature of emptying is to honor the ending of a creation and ourselves as creators. In the prior stage of releasing, the creator begins the letting-go process while still remaining connected to creation, adjusting and refining. But now it is over. In my own series work, I can always tell when that happens. I do a painting, and something in it tells me it is the last one. It seems final, although I haven't yet come to an understanding of why. I just know the energy has changed, and it's time to stop. Conclusion has crossed over into completion.

The sense of completion is a feeling to be cherished. For me, it's wonderful to see my paintings stacked up, ready to be newly hung. It shows me how much work I've done— to realize that what once was difficult to move through has now been accomplished. Also at this stage, I'm ready to let go completely of all that didn't work, those pieces that fulfilled their purpose as stepping stones, nothing more. Cleaning out the drawer and throwing things away becomes a little ritual that is important to my creative life, for emptying is crucial to the birth of other creative endeavors to come.

The Shadow Self

When we are busy with the activities of opening, closing, holding, releasing, we are engaged enough that those little dragon voices of judgment do not pull us off track. But during the emptying stage, when we feel more vulnerable to our creative loss, a larger shadow may appear, showing itself as a deep fear of risking presentation to the world. The enjoyment of creating may have been so pleasant that we really don't want to move on. When I did a series I called Love, it was such a celebratory group of paintings made over two years that I hated seeing them end. The creation process had been so filled with joy and growth that viewing them as a completed product was a difficult threshold to cross.

Difficult, too, because the threat of criticism lay in wait around the corner. I loved them, but would others love them? Would my babies, my pearls, be treated well? I wanted to protect them. But the day comes when we can't protect our babies any longer, or else we stifle the life force in an unnatural way. Pearls are meant to come out of their shells and be seen by the world. So now we face with honesty the shadow self that lurks

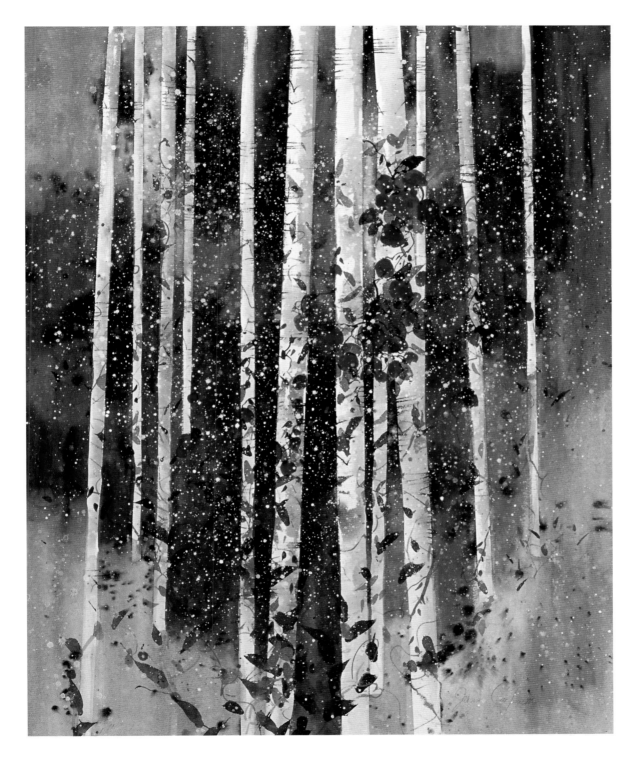

Jeanne Carbonetti
APRIL BIRCHES
Watercolor on paper,
40 × 32" (101 × 82 cm),
1997. Collection of
the artist.

*The stage of emptying
is a powerful place for
learning. There is much
behind us now. If we
practice hindsight with
alertness, we can see
the big pattern.*

Jeanne Carbonetti
CANYON
Watercolor on paper,
22 × 22" (56 × 56 cm), 2000.
Collection of the artist.

In the stage of emptying, there needs to be a full surrender to its process, a being in sync with its special rhythm.

in our psyche—the one who fears being alone and unloved. The ultimate fear for the creator is that our "good" is not good enough, that our gift was never wanted, that our dream is not allowed. We are like children wanting to explore the world but not wanting to go too far from our mother, for when we risk being ourselves, we risk being more alone and unloved. Thus, we choose a mask that helps us fit in and send everything that doesn't fit into our hidden shadow self. Until, of course, we seek to create. Then the wave of our creating carries all the parts of ourselves out into the open.

But healthy children learn that they can trust their uniqueness and still be loved. As healthy creators, we parent both our shadow and our mask, indulging neither, honoring

both. In doing this, we "re-member" ourselves and gain creative power. We are not so lonely anymore, and we gain courage to face the world. We become one "in" us, and we know we will create again.

The Larger Scheme

You may be a conscious creator who has experienced the joy of manifesting your desires, but sometimes—it just doesn't work out. You know you must abandon your dream and begin again, but you ask yourself, "Why didn't it work out? What did I do wrong?" You may attempt to keep the dream alive by trying harder, but it just doesn't help. The dream is dead, and you feel betrayed by life. But has the law of life really gone wrong? No, nothing has gone wrong in the larger scheme. All that happened is that you met a still larger cycle of creation, of which we are all an intrinsic part. We all create in small ways daily, in larger ways over time, in still larger ways over lifetimes. Even more, we are part of a web of creation, a collective consciousness that grows, learns, and creates. We are creative drops of water, but we all belong to the ocean of creativity. Remember, true creation is always co-creation.

It is a time to stop and let ourselves be emptied of our dream for awhile. We have done what we were supposed to do; there is no need for guilt. It is time now to step back and seek the bigger picture. Ocean is speaking. We need to listen.

Jeanne Carbonetti
SPRING MEADOW
Watercolor on paper,
21 x 21" (54 x 54 cm), 1999.
Collection of the artist.

Emptying does not have to be the quiet winding down accompanied by a sense of loss. It can also be a riotous burst of creation, a volcano of giving.

The Practice of Perspective

Emptying means using perspective. First we let go and withdraw our energy, allowing what is be as it is. Some of us like to keep trying, an admirable trait, but the moment comes when we cross over the line from staying with a thing to forcing it. In watercolor painting, students often give up too soon, while professional artists often give up too late. There comes a time when we need to consider it done—then, from a greater distance, look back and learn what our efforts can teach us now. Where have we been? Where are we now? This is the time for hindsight and reflection. It is a valuable part of the cycle and one that is overlooked too often.

The way to tell is by watching your energy. When you are in flow, there is a fluid, spontaneous movement from new thought to action. When you find the energy halting, it is time to take stock. In watercolor painting, there is a clear visual equivalent of this; the painting gets "muddy." Though it may be more subtle in other modes of creation, the principal remains the same.

Mirroring

The deeper practice of perspective is accomplished by the simple act of mirroring: the acceptance of everything that holds a charge for us as a picture of our inner process of thoughts and feelings that are really our own. For example, I may have a relative whom I feel is hostile. Each time I see him, he seems to "push my button." That trigger is an energetic call to face my own hostility that I have projected onto him. In this way, our shadow keeps seeking to get our attention. As we practice withdrawing our projections (both positive and negative) from other people, other situations, and our work, we empty ourselves of the encumbrances that bind our creations in unhealthy ways. We are no longer holding on in hidden ways, actually sabotaging our own success. The more we free the energies of mask and shadow, the more energy we have available for future creation and the clearer will be our connection to the authentic core of our creative self.

Stepping Back

It is so rewarding to look back at what went on with the equanimity of one seeking to grow from past experience. Stepping back allows us to cross the threshold into the next stage by simply making a ritual of cleaning out and finishing up. As I noted earlier, I always find myself ruthless in cleaning out my studio after I've completed a large series of paintings. I go at it aggressively, and it spills over into other areas of my house as well.

Jeanne Carbonetti
MOON AND PINES
Watercolor on paper,
16 × 12" (41 × 31 cm), 1999.
Collection of the artist.

In moments of stillness and reflection, we catch the wisdom of our working. It glows like a full moon in our consciousness, shedding light and understanding on our labor.

Another way of stepping back is by keeping a journal. For the more substantial task of emptying the psyche of one's personal dragons, or facing the shadow self honsetly, I find that a personal journal creates the sacred space where all is poured out to be seen more clearly. My own journal acts as a funnel, where I bring everything together: dreams, notes, reflections, meditations.

Withdrawing Energy

Recognize daily and in large cycles when it is time to withdraw your energy. Let the parting be fully realized by physically doing something that empties a space so that the old is completed and honored as such, thus freeing it for something new to form. Moreover, acknowledge daily and over time the shadow within yourself that drains you of creative energy, and take measures to shine the light of consciousness there. By withdrawing projections, you are continuously emptying both your life and your psyche of that which drains your energy. This is a beautiful way to keep the funnel of your life clear for new life to pour through you, and it trains you to receive the gift of insight.

Jeanne Carbonetti
VASE OF IRIS
Watercolor on paper,
15 × 18" (46 × 38 cm), 2000.
Collection of the artist.

At the end of the stage of emptying, we become conscious of a space in our life for new things to bloom and flourish.

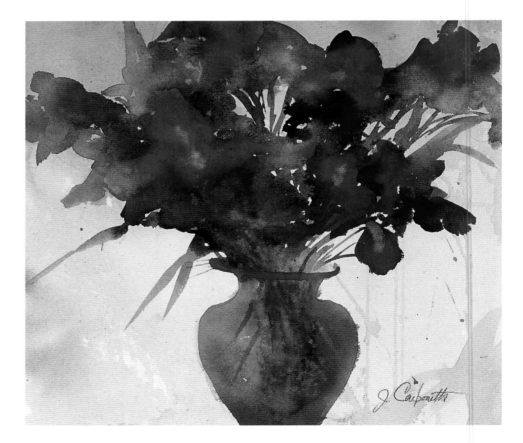

The Gift of Insight

Parting can be, as Shakespeare suggested, such "sweet sorrow." When the parting is done with mindfulness, it can be a beautiful and powerful experience that guides us into the future. We have all known times when our good-byes were weak or not enough, and times when we said or did what came from our core. When we are authentic in our emptying, the experience acknowledges the ceaseless rhythm of change and honors the great unity behind the myriad forms. Most of all, it provides a perspective that gives meaning to our present situation and a view of a larger pattern in our lives. I have come to believe there is not just a path that we choose to take, but a larger path that is taking each one of us as well. Aligning the smaller path of our personal choices with the larger path of our destiny seems to be the key to creative flow. In the emptying, the gift of such perspective becomes clear, and we are free to see the forest and the trees; the puzzle of our individual choices come together, and we see clearly. That is the greatest asset to creative life, for it is the key to our growth—and it only comes when it is over.

Jeanne Carbonetti
WHISPERS
Watercolor on paper,
25 × 20" (64 × 51 cm), 1999.
Collection of the artist.

We need all the voices within us to create—even the ones that whisper softly.

Jeanne Carbonetti
OKEMO BIRCH
Watercolor on paper,
17 × 7" (44 × 18 cm), 1999.
Collection of the artist.

At the top of the hill in the creative process, we think about what is over the ridge. As creators, we are programmed with desires that lead us forward to new adventures.

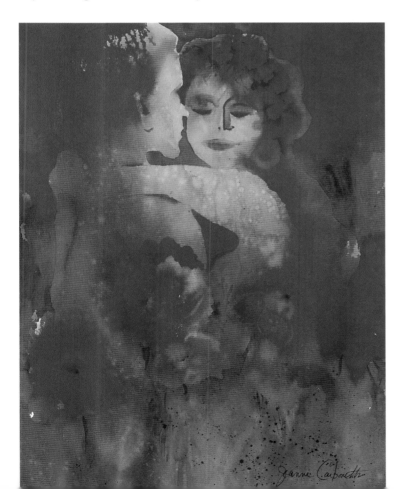

The Power of Art: Creation Cycle, Part VI

A Symbol for Emptying

In ancient art and mythology, the urn was a symbol of the goddess, the one who was in tune with the eternal cycle of filling and emptying. I have several urns in my goddess garden, reminding me that there is a time to fill, time to be full, and a time to empty. The urns are positioned along a spiral path, and I often walk on the path inward to the center, to a tall tree with a wonderful eight-foot copper snake curling around it. I kiss the Tree of Life and each of the goddesses in their turn, and so remind myself to surrender to the great cycle. It is bigger than I am.

What symbol will help you to appreciate this part of the creative cycle—emptying and parting? Perhaps it is an action rather than an object: your annual spring cleaning or your monthly trip to the recycling center? (In Feng Shui, the Chinese art of placement, the accumulation of clutter is a major block to the flow of good energy and good fortune.) The gift of emptying is that it clears the way for the universe to fill us again. We empty ourselves that we may fill once more.

Follow previous directions (page 29); for this square, color the background in any shade or shades of violet that you like—or make this square an indigo, a deeper combination of red and blue. Violet is symbolically associated with wisdom and insight; indigo, with great vision.

Into this square, place whatever words, images, or symbols suggest to you the stage of emptying. Allow yourself to move back and forth now with the other squares you've created. Use any art medium that appeals to you.

Example, background only: *My violet background has a lot of red in it, and flows in a cloudlike formation in a diagonal direction.*

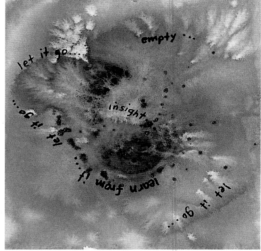

Example, completed square: *Artist Randi Dunvan used a more blue violet watercolor hue, together with indigo, then completed her square with words and phrases that evoke the stage of emptying.*

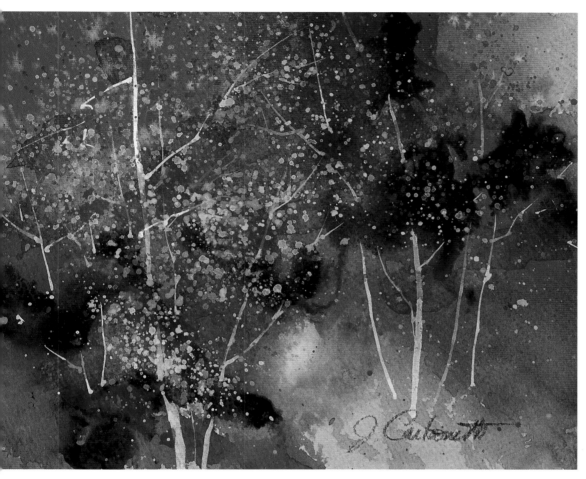

Jeanne Carbonetti
EASTER MIRACLE
Watercolor on paper, 8¹/₂ × 9¹/₂" (22 × 24 cm), 2000.
Collection of the artist.

Early spring in Vermont always thrills me. I see Mother Earth coming alive again—the first confetti of buds across the forest, reminding me of the delicacy of creation's first budding, to be tended with love and the respect that allows it to sprout in its own good time.

Meditation

EMPTYING TO A
HIGH PLACE
Allow yourself about fifteen minutes of quiet, uninterrupted time.

Take a few deep breaths, centering your body, clearing your mind, and letting everything go, except for this one focus.

Close your eyes and picture walking to the top of a lovely hill that has a broad view. Everything is bathed in a beautiful sunset of violet light.

If you have time for an extended meditation, imagine a full, star-filled sky of indigo. Let your attention focus on the area of your body known as the third eye, between your eyebrows.

Ask for guidance from a higher perspective, one that sees a bigger picture. Then simply relax and wait. The more you practice this, the more attuned you will become to how answers come to you, and you will know you can trust them.

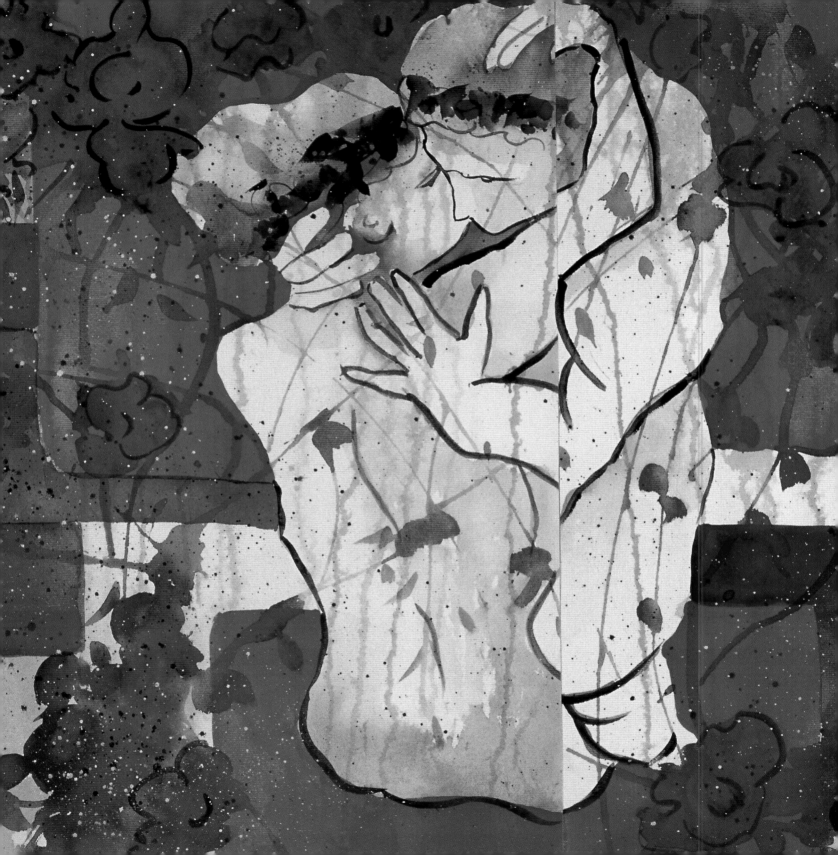

7

Sitting

Sit quietly, doing nothing. Spring comes,
and the grass grows of itself.

Zen saying

Jeanne Carbonetti
KAMA SUTRA
Watercolor and collage,
22 × 39" (56 × 99 cm), 2000.
Collection of the artist.

*The stage of sitting allows our yin and
yang nature to join in an ecstatic union.*

The Nature of Sitting

I walk on the beach, collecting shells. Now and then, as the water washes over my feet, an oyster shell is deposited onshore. When it is a heavy bivalve, I know the oyster is still inside. It has not yet returned to the stage of waiting, hungry and preparing to be fed by cementing itself somewhere. Sometimes it is a half-shell, and I wonder how the last days of pearl-making went for this fellow. Another wave comes, and both are swept away.

No matter how the process of creation has gone, the final stage is one of just sitting, resting from activity of any kind. It is the pause between our out-breath and the next in-breath, that sliver in time when it is possible, as meditation teachers tell us, for eternity to break through. If the first stages of creation—waiting, opening, closing—are the filling of the in-breath, and if the stage of holding is the momentary pause before the expelling breath of releasing and emptying, sitting is the greater pause, that special juncture in time between death and rebirth.

Transcendence

The stage of sitting is integral to the creative process, although Western culture tends to tolerate it at best, and at worst, has a decidedly hostile attitude toward its purpose. But this phase of creation has its special gifts, and they are crucial to the preparation of the next rebirth. If we work only from the assertive side of the cycle, we will gradually exhaust the soil of our generative abilities, because the seed of our creative impulse does not come from that place of doing. It can only come from the much larger world that we access through non-doing. The stage of sitting, when honored, provides the opportunity for the deepening of the creative act into transcendent experience. Every creative act is translucent to transcendence—if we allow ourselves to see.

Trust

Not to be engaged in any way is what sitting is about, and it is based on trust. After all is said and done—the grand attempt made, the dream fully realized or not, the mistakes made, the lessons learned, the shadow faced in whatever disguise this time, the personal evolution—there is now nothing we can do. We are like swimming pools that have been emptied, and it is not up to us to fill them again. The filling must come from a place larger than our egos, a place deep inside that moves us from our core—but when that will come again is a question we must live with. Thus the need for trust. We must have faith that inspiration will come again.

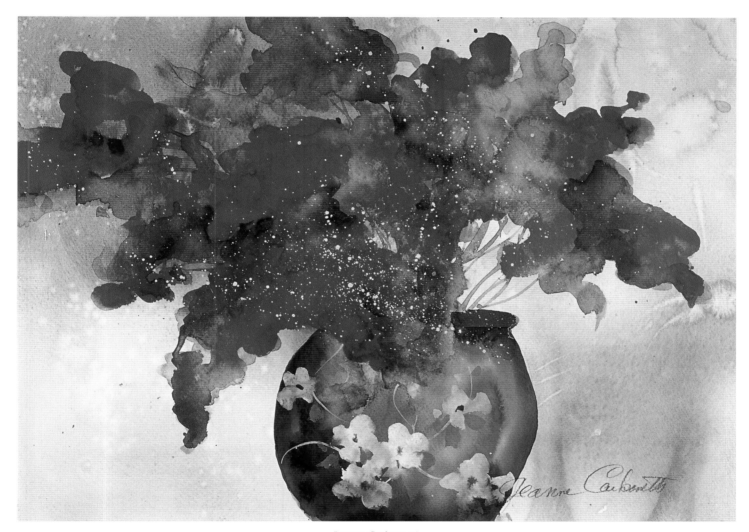

Jeanne Carbonetti
LILAC IN CHINESE VASE
Watercolor on paper, 20 × 24" (51 × 61 cm), 2000.
Private collection, Ohio.

The grace of the stage of sitting is the unexpected awareness of beauty. It presents itself to us quietly, demurely, like the shy person we've overlooked before, who now seems exquisite and like no other.

Humility

It is only when we have used up the tools of our ego that we are given the chance to glimpse this numinous presence. When we give ourselves completely to the creative process and are emptied by it, we may touch our innocence again and know the mystery of creation directly, recognizing that real power lies there, not in us.

If we think it is up to our egos to figure out, to fix, to understand, to control everything, we are bound to get tired, frustrated, and angry at the gods who abandoned us to this dilemma. One day we learn that we can't do it alone, and were never meant to try. The gifts of the larger consciousness are always available to us, but it is up to us to ask. Our pride is not that we think we do it better than others, whatever it is, but that the outcome is completely up to us. The pride that we humans suffer from is the pride of separateness. We worry that if we can't do it right or good enough, we might be rejected—not loved, more separate.

But the stage of sitting, when honored properly, is marked by a deep sense of humility. This is the most powerful and life-changing lesson that the creative process can teach us: that it is not up to us alone. We are not alone. We have not been abandoned.

Jeanne Carbonetti
SUNSET REFLECTIONS
Watercolor on paper,
20 × 20" (51 × 51 cm), 2000.
Collection of the artist.

Reflection is a necessary and powerful force in creative life. Seeing ourselves clearly, we enter the mystery more deeply.

Jeanne Carbonetti
**STILL LIFE IN
LAVENDER**
15 × 22" (38 × 56 cm), 1999.
Private collection, California

*Imagination has its most fertile
soil in the stage of sitting, when
inner voices no longer have to
compete with outward distractions.*

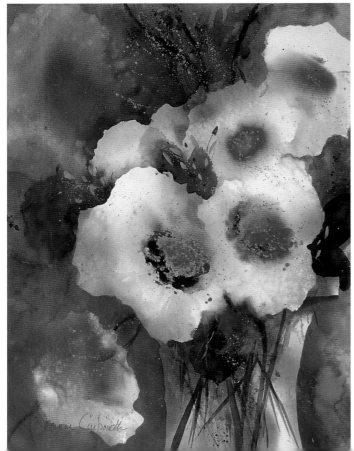

Jeanne Carbonetti
PLAYFUL POPPIES
30 × 22" (76 × 56 cm), 1999.
Collection of the artist.

*There is a beautiful mystery to
the stage of sitting, when every-
thing goes back to the quantum
field of potential. All things are
possible once again.*

The Practice of Non-Doing

It may seem silly to speak about practicing not doing something, but it is a required skill for creative life. It allows us the time for refueling. Because Western culture is so good at doing and producing, little room is left for the replenishing aspect of the creative cycle. If we were cars, we could not run without fuel; neither can a creative life. Practicing non-doing is learning how to keep a full tank of gas in our creative vehicles. Actually, it is a very enjoyable practice, and you may find that it finally gives you permission, in the name of creativity, to not do what you didn't want to do in the first place.

Honor Honesty and Intuition

The first practice of non-doing is being honest, which means fulfilling only those obligations you truly wish to honor, and not doing what you do only because you think you should. The amount of time and emotional energy to be released through this approach will astound you! Moreover, it will ultimately produce a much better flow of interpersonal relations, because your ties will be clear and true rather than forced.

Non-doing is also practiced by being intuitive rather than analytical, letting a decision come to you, rather than trying to figure it out. Probably you have experienced times when, after all the logical reasons for doing/not doing something are clear, you pause one morning and just know you need to do the opposite. This is intuitive thinking at its best, just receiving the answer. It comes from the consciousness I call Heart Mind—the synthesis of both Logical Mind (analytical) and Body Mind (instinctual). When we allow Heart Mind to speak to us, we are providing a way for all of our consciousness to come together. That is why, in my belief, the answer must always come from one's heart.

Being

Just *being* is another way to break the habit of habitual doing. It is a very subtle practice, because much of the time, we have to work at being while doing. But there are ways to recognize the state of being even in the midst of activity. One of these is by simply being mindful of whatever you are doing at the moment. If you are washing dishes, think only of the dishes, nothing else. You will then be fully present in the now, focused on one thing only, not scattered to the past or future.

Allowing all things to be as they are, without trying to change them, is the purest form of just being. In painting, this is a powerful lesson, for as an artist, you must simply respond to the new dynamic balance of every moment. One of the surest ways of killing a picture is by trying to "fix" it, to make everything fit together too closely.

Pausing

Finally, if you pause before reacting to a stimulus, you will give yourself time to make a new choice, which in turn allows you to be fully conscious in the moment. It is a manner of releasing a new event from past categories, a forgiving of the past. If, for example, your stomach tightens every time your boss walks into the room, notice it the next time and breathe slowly. Noticing your breathing is a form of being with the experience. The awareness you now bring to the situation takes you out of automatic response to conscious response. Pure being is a consciousness in the present moment; an automatic reaction is thus not an aspect of pure being. Spontaneity is, because it comes from the consciousness of real decision. "Let's go get ice cream," you say. For a second I pause, feel moved to answer, then decide: "Yes!"

Try to incorporate the practice of non-doing into your life in whatever way is appropriate. As decisions confront you, give intuition its say. In encounters with others, pause to let awareness of your actions come from the spontaneity of all of you. When faced with the next event that you "must attend," consider the possibility that you need not go. Come from the place of truth within you, and you will go to a plane of reality that is deeper than the place of judging. Then you will know the bliss of being.

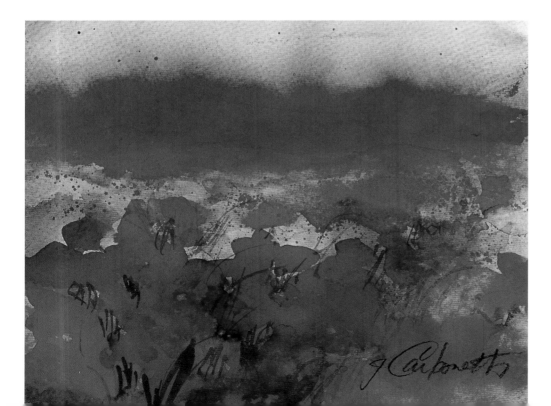

Jeanne Carbonetti
CAPE COD SUMMER
Watercolor on paper,
8 × 10" (21 × 26 cm), 1999.
Private collection, Ohio.

There is a singularity in the stage of sitting. It allows events and recognitions to flow into one contemplation, and an inner balance, essential to creativity, is achieved.

The Gift of Grace

What the creative cycle teaches us ultimately is the lesson of grace, the paradigm shift that pulls us out of our sense of separateness into the ground of being that is the source of every creative impulse. We are like drops of water on the sand that have merged back into ocean and suddenly recognize that we are not puny little droplets—we are ocean! If you go into the creative cycle deeply enough, honoring every stage of the cycle, you will arrive at this place of wholeness. It matters not what you seek to create. If you engage the path of creation, it will take you to the center of it all—to the Self.

When we come to that place, we have awakened to an understanding that we are spirit first, all else—bodies, minds, egos—after that. Behind the world of forms—the world of I and other, the world of duality—there is the world of unity. Starting from one, you always reach the other. From the one, to the many, back to one. The creative cycle has taken us from the intensely individual to the purely universal. To come to this awareness is beautiful, but to feel it is an act of grace. We cannot make it happen through any act of will or ego. We can only place ourselves at that juncture of consciousness where it is possible that Heaven can touch Earth. This is what we do when we sit.

Jeanne Carbonetti
MOON AND MORNING GLORY
Watercolor on paper,
20 × 20" (51 × 51 cm), 1999.
Collection of Norma Meier.

If we allow ourselves to surrender to it, there is a sweet peace that comes in this stage of sitting. It is a time for not being moved, for allowing all things to be.

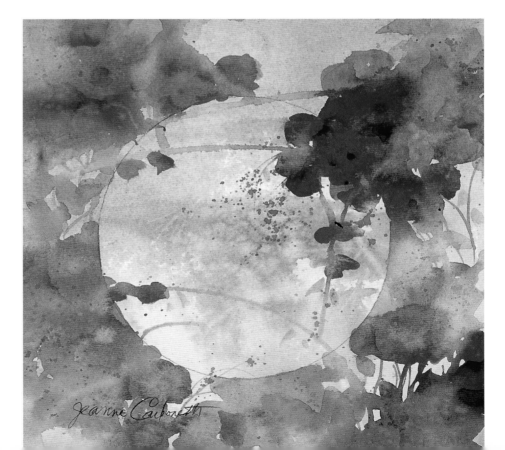

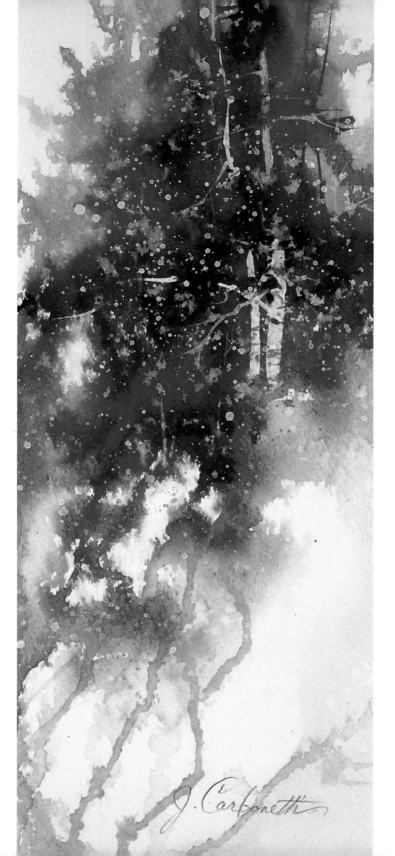

Jeanne Carbonetti
WINTER IN VERMONT
Watercolor on paper,
30 × 10" (76 × 25 cm), 1999.
Private collection, California.

It is good to be as quiet as possible in the stage of sitting, to allow the mystery of inspiration to do its hidden work. The most powerful motives spring from the core of quietness.

The Power of Art: Creation Cycle, Parts VII and VIII

A Symbol for Sitting

A Symbol for Sitting

My favorite symbol for the stage of sitting is my statue of the seated Buddha. He sits in my garden on a knoll among tall pines. Each time I go to my gallery, I pass him and am reminded to allow myself to be moved by the flow of a greater destiny. I have learned throughout the cycle of creation to partner with life rather than force it to follow my will. Now I let it carry me, seeing where it goes, having faith in the grace of my path.

What is your symbol for the beauty of sitting, the grace of being? At the close of the cycle of creation, when you are just sitting, allow yourself to be moved by the flow of destiny, and if you sit long enough, you will be deepened by it. The soil of your creative life will become richer from the previous planting, and a new seed will find a fertile ground to begin a new birth.

For the final two pieces of your art series, follow instructions given earlier (page 29), but this time, color two squares: violet for the seventh if your sixth square was indigo, or white if your sixth square was violet.

For your summary square, the eighth, use any color(s) you choose. Adjust any squares as you see fit. You may now frame each square separately and hang them as a series—or hang them together as one work in any configuration you like (examples are shown in the next chapter). You might also make your own prints. Color-copy each square, reduced a bit in size, then put them all together on one sheet and copy again. You will have a beautiful print that is a true record of your generative experience.

Example, background only: *For my seventh background, I worked in very diluted violet watercolor, to let lots of light show through.*

Example, completed square: *Artist Rita Malone's summary square combines subtle shades of several colors used in her earlier art (see page 17).*

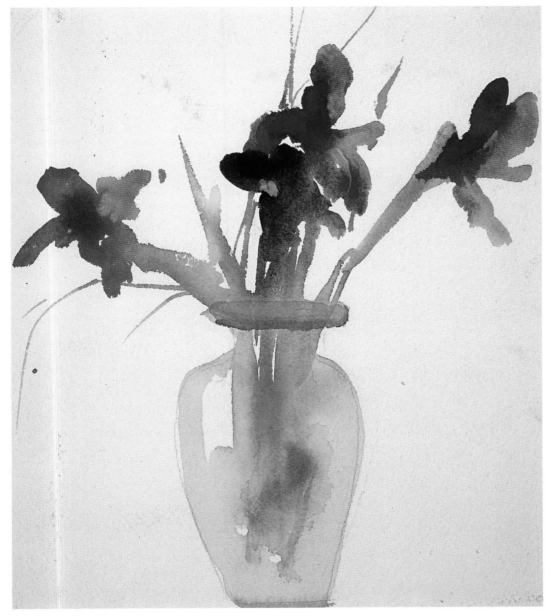

Meditation

SITTING IN THE LIGHT
Allow yourself ten minutes
or more.

Close your eyes and
relax your body and mind by
breathing deeply a few times.

Visualize a golden-white
light, like a sun, somewhere
over your head, pouring its
light down over you. Let it
move down into you now so
you are a ray of that sun. Just
hold that light, and enjoy.

Jeanne Carbonetti
JAPANESE IRIS
Watercolor on paper, 6 × 5" (15 × 13 cm), 1998.
Collection of the artist.

When there is enough of a space of non-doing, all things become illuminated,
and every contemplation brings wisdom.

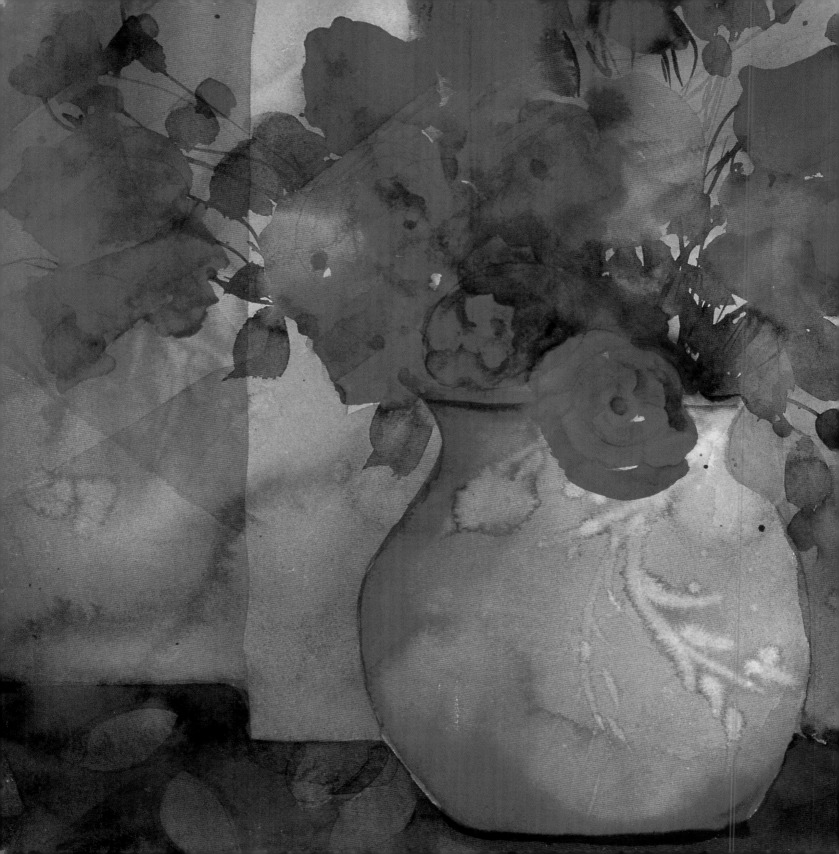

8
Conclusion

He who knows others is wise;
he who knows himself is enlightened.

Buddha

Jeanne Carbonetti
BLUE AND ROSES
Watercolor on paper,
25 × 20" (64 × 20 cm), 2000.
Collection of the artist.

*There is both power and serenity in
knowing your own self in the creative
cycle. There is serenity in knowing that
there is a universal law at work and you
recognize the power you possess to work
with it consciously.*

The Pearl of Wisdom

What is the very heart of the creative act? At its essence, it seems to be spirit seeking material form; a desire that we have on the inside seeking to become form outside of us. We seek to embody what represents us, and that impulse needs us to give it structure. It is Heaven and Earth seeking each other.

Thus we are all programmed for creation. Our instinct to desire is our divine nature seeking fulfillment, and our willful thought is the mold that holds the desire until it is fully formed. Like the artist who reads his painting for a mirror of his deepening process, so every creator can read his own world of creation for clues into the ever deeper mystery of his soul's growth.

Creation on every level is a training in consciousness. In order to create, we must make choices that begin to limit the world of potentiality into the more concrete reality of that which we feel, know, love, and want. As we move through the cycle of creation, we must learn to understand and honor ourselves as creators, giving voice to all the parts of ourselves and recognizing their own unique dance within us. Body, mind, and spirit—the mother, father, and child in us—all need to be present for creation to take place, to thrive for our consciousness to be whole.

Shared Traditions

While the image of an oyster making pearls has long been my perfect metaphor for the creative cycle, it is only recently that I have begun to realize its affinity to several major traditions of consciousness development: among them, the Hindu Chakra system (which corresponds to the Western medical glandular system), the Hebrew Tree of Life, and the Christian Sacraments—and some of these parallels are summarized below. I'm sure there are still others. What they all have in common is a seven-tiered structure that delineates an increasing complexity of understanding and function. Each succeeding stage depends upon the awareness and development of the one before. (For excellent, in-depth discussions of these congruities, I recommend two books: *Anatomy of the Spirit* by Caroline Myss, and *Eastern Body, Western Mind* by Anodea Judith.)

Parallels

If we are grounded in the stage of waiting, corresponding to the sacrament of baptism, then we are able to open effectively—the stage in the creative cycle where we receive from many sources, allowing ourselves to remain fluid, like the water element of the

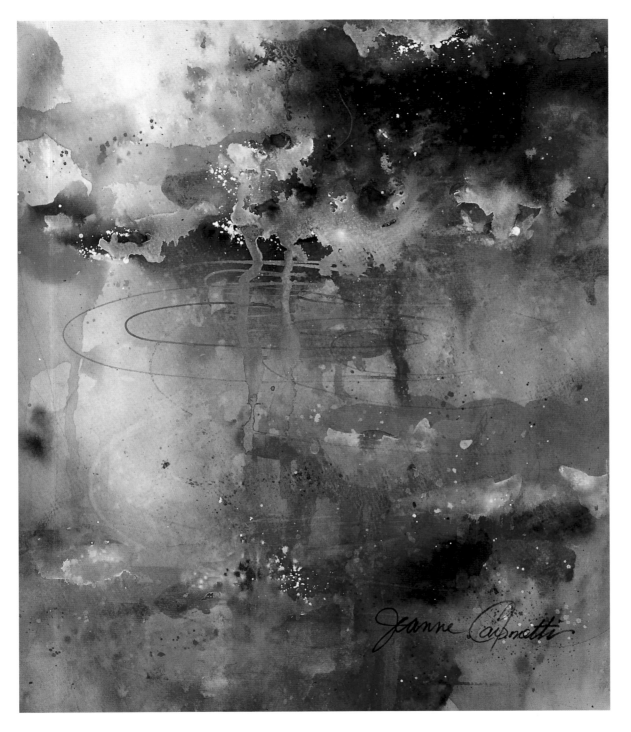

Jeanne Carbonetti
MIDDLEBURY POND

Watercolor on paper,
20 × 17" (51 × 43 cm),
2000. Collection of
the artist.

The pearl of wisdom that we learn from the creative cycle is that we can trust our own process. We need only honor it by allowing all its phases to do their work.

second chakra—until we find our true "communion." When one closes in stage three, the creator is exercising the fire of his own will, symbolized by the sacrament of confirmation.

The fourth stage of holding is the midpoint in the creative cycle, and as in all the other traditions, it is a place of balance, where polarities are brought together and held until they are fulfilled in the sacrament of marriage. When the two become one in the heart, love is born.

The stage of holding is the plateau of the creative cycle, the balance of the forces of building up and those of letting go. Where stages one, two, and three are Earth-centered, stages five, six, and seven are the stages in the cycle that correspond to the Heaven centers of the Chakra system. Releasing, in stage five, is the expression of one's truth in form. We hold our dreams in our hearts and work to bring them into form first within ourselves. But as we seek to give them form in the outer world, we let them happen, releasing them from too much control on our part. One's personal truth, the sacrament of confession, becomes the Truth.

In the stage of emptying, we have entered the realm of the third eye, the seat of spiritual intuition and wisdom in the Hindu Chakra system. In this stage one begins to detach one's energy from a given dream in the creative cycle. Corresponding to the sacrament of ordination, every effort is ordained to serve the path of our growth in consciousness. A much greater perspective is possible now.

Finally, in the beautiful stage of sitting, there is only grace. As the sacrament of divine unction would suggest, the creator lets go of everything and rests in faith that one day, the cycle will be spurred again. We release ourself to the other, out of which rebirth will eventually come. The unity of all things is the realization of the crown chakra.

What is so beautiful about the cycle of creation is that it is yet another demonstration of an exquisite order of which we are an intrinsic part. The body itself, with its spinal cord and DNA spiraling upward and downward, is the very blueprint of spirit and matter, Heaven and Earth, seeking each other. We are the Tree of Life at the center of Eden, and every creative act we initiate moves us upward from our root to the fruit of consciousness, allowing spirit to descend through us as once it descended in us.

Birthright Claimed

The pearl of wisdom to be remembered from this is that we are already creators; we have only to claim our birthright consciously. The way we do that is by simply acknowledging the rhythm of our creative cycle. If we recognize where we are and honor it, we will be in flow with our true creative power. Likewise, we will see where we throw ourselves out of rhythm by not honoring the true nature of each valuable stage. With every creation in every arena, we will have a mirror of our growing consciousness, not just where we have been, but what we are being called to become.

The soul is always calling, and with every conscious act of creative living, we answer. Through our awakening, Heaven and Earth are one again, and we see the truth at last: We are not only makers of pearls; we are the pearls we make.

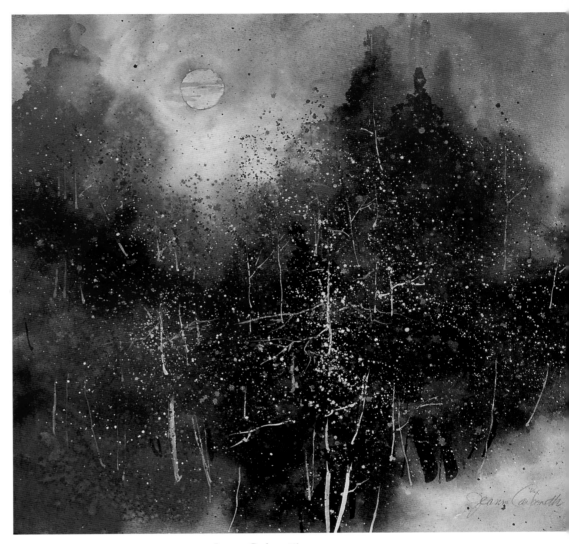

Jeanne Carbonetti

ABOVE:

SANTA FE MEDLEY

Watercolor on paper, 20 × 20" (51 × 51 cm), 2000. Private collection, New York.

No tree can bloom without strong roots. Fresh from the start, we need to be grounded, claiming our space and right to create.

LEFT:

HILLS OF POMFRET

Watercolor on paper, 30 × 8" (76 × 20 cm), 2000. Collection of the artist.

The more consciously one creates and lives, the more colorful life becomes.

107

Completed Creation Cycles

The next three pages contain the completed Creation Cycle art by student colleagues of mine whose work you have seen in earlier chapters as examples of various stages of the process. Each group is arranged in a different configuration, to show some of the ways you might display your completed sequence.

Whether you express youself through art or another, completely different channel, the important thing is to keep creating, moving through the creation cycle again and again so that you will learn to recognize how you create—where you tend to hold yourself back, where you move smoothly. Remember, it is your purpose in life to create and to know yourself as a creator—and I wish you well in your quest.

Jeanne Carbonetti
MORNING LILIES
Watercolor on paper,
15 × 13" (38 × 33 cm), 2000.
Collection of the artist.

Creation flowers whether we are conscious of it or not, for it is a law of life. But when we embrace the creation cycle, we add a powerful force, nurturing its growth.

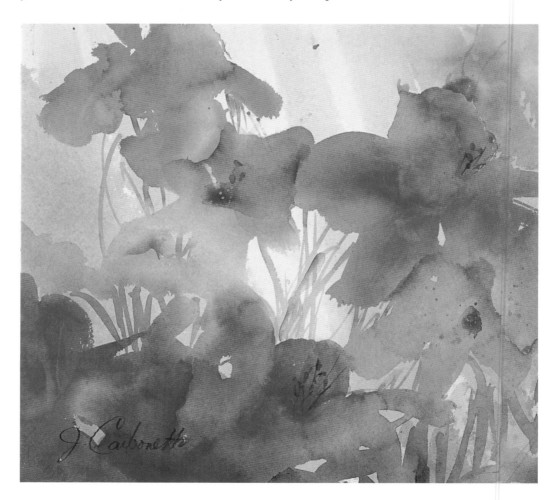

Laurie Marsh
CREATION CYCLE
Watercolor and collage on paper,
eight 7" squares, 2000.
Collection of the artist.

Laurie found that the building of a Creation Cycle on paper helped to make her understanding of the stages much more concrete and substantial than just theoretical.

Arranged as a consolidated grouping, Laurie's earliest stages are placed at the bottom, building up to the final stages at the top.

Randi Dunvan
CREATION CYCLE.
Watercolor and collage on paper, eight 7" squares, 2000.
Collection of the artist.

*This compact arrangement would be mounted in one frame, with the stages of creation
flowing in sequence horizontally. Following the making of her Creation Cycle, Randi
began to notice a profound understanding of events in her life as mirrors of her process.*

Andy Swenson
CREATION CYCLE
Watercolor and collage on paper,
eight 7" squares, 2000.
Collection of the artist.

*These images are shown as they
might be hung in a lively stepped
display. Andy had not made art
before, and it was a breakthrough
experience to create a form that
contained his ideas. Each gave
dimension to the other, and a real
synergy took place that is the
heart of creative expression.*

111

Index